Bernard Leach: a potter's work

with an Introduction and Biographical Note by J. P. Hodin

Bernard Leach a potter's work

KODANSHA
INTERNATIONAL LTD.
Tokyo, New York & San Francisco

Published by Kodansha International Ltd., 2-12-21, Otowa, Bunkyo-ku,
Tokyo 112, and Kodansha International/USA Ltd., 10 East 53rd
Street, New York, New York 10022 and 44 Montgomery Street, San
Francisco, California 94104. Distributed in the United States
by Harper & Row, Publishers, Inc., 10 East 53rd Street, New York,
New York 10022. © 1967 Bernard Leach and Evelyn, Adams & Mackay
Ltd., (Adams & Dart). All rights reserved. Printed in Great Britain.
LCC 73-92991
ISBN 0-87011-226-0
JBC 1072-784407-2361

Foreword.

I have selected the illustrations for this book myself, covering the fifty five years between 1911 and 1966.

The pots and drawings were chosen from those photographs, or originals, which were available, for the greater part of my work is scattered in England, Japan and elsewhere. Nevertheless I think this collection is fairly representative.

I have some reticence in writing about my own work, other than marginal comment, because both drawings and pots have their own silent languages, and they must stand or fall by the reactions of other people.

Bernard Leach 1966

contents

introduction

Biographical Note

Bernard Howell Leach was born in Hong Kong on 5 January 1887. He is the son of an English Colonial Judge with some Welsh ancestry. His great-great-uncle was Sir John Leach, P.C. (1760–1834), Master of the Rolls and Chancellor of the Duchy of Cornwall. Bernard Leach cherishes their memory and pictures of both hang on the wall of his apartment. In the year of his birth Bernard Leach was taken to Japan, in 1891 from Japan to Hong Kong, and in 1895 to Singapore. In 1897 he travelled to England for the first time via the U.S.A. He was educated at Beaumont Jesuit College, near Windsor, from 1897 to 1903. At the age of 16 (1903) he went to the Slade School of Art and studied drawing under Henry Tonks, and in 1908 the technique of etching under Frank Brangwyn at the London School of Art. At 21, in the spring of 1909, attracted by the writings of Lafcadio Hearn, Leach returned to Japan. He was there for two years, drawing, painting, and making etchings, before he threw his first pot. He actually introduced etching into Japan, having brought an etching press with him from London. He married a cousin, Muriel Hoyle, in 1911, and at that time had an income of £100 a year which his father had left him. He remained in Japan, with the exception of short periods in Peking (1916–18)[1], for eleven years. In 1911 his son David was born and in 1913 his son Michael, both in Tokyo. They, too, are potters. So are David's sons John and Jeremy, the third generation. Bernard Leach also has three daughters. In 1911 Leach, full of enthusiasm, took up the craft of pottery under the representative of the sixth generation of Kenzans and became well known for his etchings, drawings, and pots before he returned with his family to England. In accordance with custom, the head of a school allows his best students to use his name, his palette, and glazes. Bernard Leach and his friend Kenkichi Tomimoto represent the seventh generation of the Kenzan tradition through the certificates of proficiency which they received from their master. Its first representative, Ogata Kenzan (brother of the painter Korin) was famous about 1700 for

[1] In 1916 he visited Peking for the first time; in 1917 he moved to Peking with his family. In 1918 he returned to Japan and built his first stoneware kiln.

his use of a wide variety of colours, his fine calligraphy, and his brushwork.[1]

In Japan, Leach was closely associated with a group of young writers and artists whom he interested both in contemporary craftsmanship and in the preservation of Japanese traditions of craft. In this activity he had the companionship of the late Kenkichi Tomimoto (who died in 1963), and towards the end of Shoji Hamada, both of whom he inspired to become potters. The most active spirit behind the movement for the preservation and survival of the old tradition in the crafts was the late Dr Soetsu Yanagi (who died in 1961), a lifelong friend whose interest Leach helped to engage on behalf of the crafts.

When Leach returned to England in 1920 he was accompanied by Shoji Hamada, with whose help he founded the Leach pottery at St Ives in Cornwall. On sloping ground they built a traditional Eastern kiln, which consisted of three chambers and was fired with wood. A second kiln was built in 1922 with the help of one of the most skilled pottery technicians in Japan, the late T. Matsubayashi. In 1937 the kiln was converted to oil firing, and in 1957 Bernard Leach's present wife, Janet, built herself a kiln in the pottery for firing saltglaze ware. Shoji Hamada remained in England with Leach for three years. He then returned to Japan and started his own now-famous pottery at Mashiko.

The work of Bernard Leach and Shoji Hamada soon became known in England, but in the early years it was often money sent from Japan for pots made at St Ives that kept the wolf from the door. Good students began to come—Michael Cardew (August 1923–June 1926), Katharine Pleydell-Bouverie (January 1924–end of 1924), Norah Braden—and much of the production was done by them. More than a hundred pupils have worked at the pottery up to the present. In later years local boys were taken on and served a five-year apprenticeship. Student apprentices came from all over the world—from Japan, India, Egypt, Jamaica, South Africa, New Zealand, America, Canada, Scandinavia, and Belgium.

In 1929 the Japanese Craft Movement was founded by Dr Soetsu Yanagi, Shoji Hamada, and Kanjiro Kawai.

In 1929 Leach built a small pottery at Dartington. In 1934 he was invited to Japan as a guest of the National Craft Society and went out to the East in the company of his friend, the American painter Mark Tobey. They also visited China together. In the same year a biography of Bernard Leach was published in Japanese by Dr Ryusaburo Shikiba. Bernard Leach stayed a year and held several exhibitions of his work, both drawings and pots, in Japan and Korea. Japan

[1] In 1966 Leach published a book on him: *Kenzan and his Tradition*, Faber & Faber, London.

particularly was known for the value it set on pottery-making through the ceremonial drinking of tea, Cha-no-yo—which is regarded as a means of imbuing everyday life with beauty.[1] In 1935 Leach returned to Dartington and St Ives. In 1944 he married Laurie Cookes.

In 1940 *A Potter's Book*, with a first chapter entitled 'Towards a Standard', was published. It gives a detailed account of his 'recipes' and technical processes and relates how he became a potter. ' "The book" or "bible", as it is often termed, stimulated healthy creative ideas in many thinking people, who are concerned with the spirit of living. In fact it contains a philosophy of potting, but it is a philosophy which is indeed applicable to all the arts. Leach was the first to point out many facts which are now taken for granted.'[2] This work brought contacts from far and near. In 1949 Leach visited Scandinavia at the invitation of the Danish Arts and Crafts Society. *A Potter's Book* led also to its author's first American tour in 1950, when he was awarded the Binns Medal by the American Ceramic Society. He also received a Gold Medal in Milan. The first travelling exhibition of his work, arranged by the I.C.A. in Washington, took place at this time and was shown in American museums from coast to coast. In 1950, too, *A Potter's portfolio. A Selection of Fine Pots* was published in London. It contains Bernard Leach's aesthetic *credo*.

In 1952 the first International Craft Conference of Potters and Weavers was held at Dartington Hall in Devonshire. It was initiated by Bernard Leach and sponsored by Mr and Mrs Leonard Elmhirst. Dr Soetsu Yanagi and Shoji Hamada were the Eastern delegates. Together with Bernard Leach, they subsequently toured and lectured right across the United States, speaking on the Conference and drawing attention to the Oriental approach to crafts. Leach then continued with his friends to Japan and spent a couple of years working with the craftsmen in many parts of that country, lecturing, drawing, and holding exhibitions of work, both pots and drawings, done during his visit there. Meanwhile his two sons, David and Michael, were in charge of his pottery at St Ives.

Leach returned to England in 1954. He kept an illustrated diary of his journey, which was first published in Japan. In 1960 an English edition was brought out in London under the title *A Potter in Japan, 1952–55*. In 1955 David and Michael

[1] *The Book of Tea*, by Kakuzo Okakura, Charles E. Tuttle Co., Vemont and Tokyo, 1959. Daisetz Teitaro Suzuki, 'Zen and the Art of Tea', in *Zen and the Japanese Culture*, Routledge and Kegan Paul, London, 1959.

[2] Quoted from Barry Brickell, 'The Colonial Response to Leach', in *Bernard Leach: Essays in Appreciation*, Wellington, New Zealand, 1960.

Leach left St Ives and started their own potteries.[1] In the same year Bernard Leach married Janet Darnell, an American potter whom he came to know when she was working with Shoji Hamada in Japan. She has been in charge of the St Ives pottery since 1956. She and Bernard now produce only individual pots.

During the Second World War, Leach was a member of a National Committee looking after the craftsmen's interests. The Government then would not recognize craft for itself, only as a branch of industry. Utility regulations had a quite devastating effect on the crafts. Out of 2,000 craftsmen, less than twenty workshops were left, and most of them were led by old people. This situation has improved gradually. In 1947 Bernard Leach still complained about the crafts being subject to the Board of Trade, which could direct labour. 'There is no final authority in matters of art and crafts yet. We don't want any Ministry, we don't want to be subject to politics. But we are hoping that we may have an Arts Commission in the House of Commons in case a vital decision has to be taken to protect our position.' Leach had an enormous influence on the standards and ethics of the British craft movement. The outcome of these reforming endeavours in the 'forties was the Crafts Centre of Great Britain, which receives an annual grant from the Treasury. In 1965 the British Government at last created a portfolio of culture. By then Bernard Leach had become 'the grand old man' of the craft of pottery in England and elsewhere.

In 1960 Leach was invited to the U.S.A. to lecture and teach for the second time. During a 10,000-mile tour which he undertook with his wife he held exhibitions of his work in New York and Washington.

Bernard Leach has been in Japan eight times altogether:

1. In 1887–1891, as a child.
2. Spring 1909–spring 1920.
3. One year in 1934–5.
4. Two years 1953–4.
5. Seven months in 1961–2.
6. Nine months in 1964.
7. Three weeks in spring 1966.
8. One month (November–December) in 1966.

In 1961, as an acknowledgement of his achievements, he received an honorary

[1] David joined his father in 1930 and subsequently became a partner. Michael joined the pottery in 1950 and worked there for five years.

Doctor's Degree (Hon. D.Litt.) at the University of the South West (Exeter), and a large retrospective exhibition was organized by the Arts Council in its gallery in London, where 232 works were on show. In May 1966 he was awarded the Order of the Sacred Treasure 2nd Class in Tokyo. It was presented to him by Mr Fukuda, the Vice-Minister of Art and Learning, and is the highest Japanese honour given to a British commoner.

Bernard Leach and The Modern Movement

Bernard Leach is the grand old man of contemporary studio pottery, the leading figure of the modern movement in the Western hemisphere. The standard of his work; its place in the hierarchy of artistic values; the stature of the artist himself; his contribution to the revival of Western pottery; the new peaks of achievement reached by him in its development; his spiritual roots in the West and his ethos as a craftsman, which made him open the golden gates to the East; his belonging to both the East and the West—all this secures him a unique position within the modern movement.

'Modern' pottery was initiated in France. From there the development moved to Scandinavia, then to England. The English movement started, in fact, with Bernard Leach and Hamada when both established themselves in St Ives in 1920. William Staite Murray comes into this picture, too. He is the only man who, in Bernard Leach's eyes, counts in the new development in England. Murray began to experiment with pottery around the year 1915 (low-temperature wares with brush decorations in colour). By the time Leach and Hamada arrived in England, Murray was already wrestling with the problems of very high temperatures and working under the inspiration of Sung pottery. In the early nineteen-twenties, under the influence of Shoji Hamada and Bernard Leach, his style changed con-

siderably. William Staite Murray conceived his stoneware pieces as abstract works of art, a conception to which Bernard Leach is basically opposed.

It was the interplay of the 'inside' of the East and the 'inside' of the contemporary West that produced the new movement.

What the English potters learned from France was something of their technique. There was not very much of a spiritual influence discernible. One ought to mention here that the French movement was premature and that is why it petered out. It did not produce a single outstanding potter. The best-known names in this early development are Theodore Deck, Auguste Delaherche, Ernest Chaplet, Jean-Charles Cazin, followed by Emile Le Noble and Emile Decoeur. The primary cause of this French renewal was the impact of the applied arts of Japan shown at the 1867 Exhibition in Paris. The Japanese colour prints were the beginning of Impressionism. Of course, there was an earlier influence on potters, too. It came from the Dutch of the sixteenth century and was inspired by the Chinese ware which reached Holland by way of its Far Eastern merchant fleet. Thus it entered as *chinoiserie* into early industrial work. The pots from Japan (for instance, Raku tea bowls, mostly late Japanese tea ceremonial ware) stimulated Decoeur and the other French potters. This late ware belonged to a decadent period; in other words it did not come from a vital, living tradition. Leach described to me the shape of Decoeur's pots as 'blueprints carefully drawn, precise and without vitality, rather than organic wheel-thrown forms', a trend which persists to this day in Denmark, Sweden, and Finland. Decoeur was an old man when Bernard Leach went over to France with Muriel Rose in 1951 to see him. He lived just outside Paris.

Apart from the influence of the Far East, what was most remarkable in the work of these French pioneers was the insight that told them, on the one hand that art and craft must collaborate to achieve soundness (Deck, Chaplet), and on the other that they must be rooted in their own rural tradition (Delaherche). In the English development Cazin is of special interest, although his influence was only slight. Working in stoneware with floral decoration in the debased Japanese style described above, he was appointed a teacher at the Lambeth School of Decorative Art. There he met Robert Wallace Martin, one of the family of four brothers who had been experimenting since 1868 with saltglaze stoneware pottery, and were using the Fulham pottery kiln for this purpose. They must be considered as the first English artist- or studio-potters. Then there was Reginald Wells, a sculptor who became a potter in 1909 and produced earthenware with a brownish glaze, some of which he decorated with white slip. He turned for inspiration to the English

tradition. Subsequently, under the name of 'Soon Ware', he produced his version of Chinese Chün ware, fired at earthenware temperatures.

What did the French and English precursors achieve? None of them radiated any great vitality. The Martin brothers based their work on the European tradition, which came from Germany (saltglaze stoneware, Bellarmines, or Greybeards of the thirteenth century), the only real European tradition of stoneware. They also made contact with Cazin, who, as we have already noted, worked from the Japanese stoneware tradition, which originated in China.

The stimulus moved later on from Paris to Denmark, where it was taken over mainly by the Royal Copenhagen Porcelain Factory. Bernard Leach met the director, Christian Christensen, some fifteen years ago in Copenhagen. They hoisted the Union Jack to honour him, and Mr Christensen also gathered their scientists and ceramic engineers to answer all his questions concerning technical problems. This was quite extraordinary. In this way they discussed the imitations of later Chinese porcelain, of celadons, *sang-de-boeuf*, copperglazes and many other things.

The question as to whether there are any modern potters of standing who have developed their styles apart from Far Eastern influences, and what the Western contribution has been to the modern movement, might be of interest here.

In the opinion of Bernard Leach, Western industrial pottery and china has not been so much influenced by Oriental form as by Oriental glaze and décor pattern. Its roots of form were undoubtedly in Greece and in the Renaissance. The most favoured English exponent is Wedgwood, in whose work the Greek influence is very strong and corresponds to the neo-classical style in architecture.

The architect is to Bernard Leach the master of the house. It is within the architect's proper sphere to co-ordinate the arts and the crafts. Gropius tried to achieve this in his modern medium, and so did Le Corbusier. As Leach says:

In the studio pottery of this century, the main influence has been, not from the classic style, but a reaction against its dominating role in the industrial field. It came, as is well established nowadays, from Sung—China, from the Japanese tea ceremony wares and country pottery. And this has been exemplified in masterly fashion by Hamada. The influence of Japan brings in the asymmetrical principle of form and décor. The same principle has, in its time, influenced contemporary painting. Ever since the invasion of the Japanese colour print, the accent has been on a style which stood in opposition to the neo-classical. The Greco-Roman style was based on symmetry. Japan, far more than China, fostered asymmetry, the use of rough clays, of heavy glazes, the irregular treatment of the surfaces. Therefore, by reason of that influence, not only directly on pottery but

through the modern painters who have been inspired by Oriental arts, one and the same stylistic idea dominates the entire world today. The East has penetrated into Europe; the world is in the melting pot. [Leach is aware, and painfully so, that the opposite movement is also a fact, more so than he likes it to be: the penetration of the West, particularly of its rationalism, its science, its technology, into the East.]

Speaking of the more recent French development after the early stoneware movement around the turn of the century, Leach described it as only of yesterday. The most original creative potters, according to him, are Francine del Pierre and Norbert Pierlot.

In the modern movement in England we must first mention William Staite Murray's pupils: Phillip S. Wadsworth, Heber Mathews, Reginald Marlow, R. J. Washington and H. S. Hammond. And there was the very gifted Sam Hayle in Dartington, whose promising career was cut short by his early death.

Among Bernard Leach's most outstanding pupils we find Michael Cardew, Norah Braden, Katharine Pleydell-Bouverie, Bernard Leach's son David, William Marshall, Dorothy Kemp, Harry and May Davis, Alix and Warren Mackenzie, Atsuya, the son of Shoji Hamada, Richard Batterham, Dick Kendall, Kenneth Murray, Laurie Cookes, John Reeve, Len Castle, and others. There was also the very promising Kenneth Quick, who was drowned at an early age in 1963, on a visit to Japan. His pots, said Bernard Leach, were very good to the hand and very good to the lip; they were satisfactory in style, but remained undeniably in other people's orbit. In fact, his style was a mixture of Hamada's and Leach's. David Leach, a good potter himself, has been of enormous help to his father. At the time when the pottery was putting up a hard fight, David, then about 21 years old, stayed with him to help to pull the pottery through those difficult years. He formed a coherent group of potters, was a good teacher and organizer. He worked in the pottery for about twenty years and left when he knew that he had achieved what he had set out to do, to start his own pottery, which enabled him to develop a personal style.

There are three other outstanding modern potters in England at present whose styles have developed in a very personal manner: Janet Darnell-Leach, the wife of Bernard Leach, Lucie Rie, and Hans Coper. In a letter to the author Bernard Leach said of them: 'Janet, Lucie and Hans are, I feel, all three significant potters in England. I think I can say this the more freely because none of them shows any direct influence from me in their work. It varies, as they vary, greatly in temperament, and that is as it should be, for true modern pots in particular are the pro-

jections of their authors. Janet's work is adventurous, free, often large and well contrived, contemporary and yet showing a primitive eclecticism. Hans Coper also goes back to old roots in a modern way, to the Etruscans and Egyptians, but in both cases it is a fine selective creativity based on natural character which compels admiration. Lucie Rie's pots are also true to her nature and alive with her personality—quiet, reliable, fine, very much the work of a woman. One is not surprised that her roots are in old Vienna, Coper's in Germany, and Janet's in America.'

There are counter-movements of course, against the standards and principles for which Bernard Leach stands,[1] but he did not feel he could say, to date, that there was a potter amongst them whose work he could wholeheartedly admire. 'Their form and pattern is derived largely from modern abstract art. It is a purely aesthetic movement. They use rough clays, thick glazes and a wide variety of techniques often originating in the Far East, or rather in Japan via America. It is ''modern'' but very contrived. There is a wide-spread desire to escape from the circle dictated by the potter's wheel and from pottery made for use. Their argument would doubtless be that industrial pottery provides sufficient of what we need in this respect. Hence much arid aestheticism. I witnessed extreme examples of this attitude in America a few years ago. The slab-built pots still had from two to six chimneys on top, but the chimneys were now closed to indicate that the pots were works of art. Such pots are not concerned with the normality of life, not even when they are made by such a man of genius as Picasso.'

The break with the basic concepts of pottery, the earthquake, goes back to Cubism, to the Cubist principle of an absolute rejection of the European tradition, for that is what it boiled down to. They threw out the baby with the bath water:

In Scandinavia, mainly in Denmark and Sweden but also in Norway and Finland, the artist potter is called engineer potter or ceramic engineer, and unlike England he works in and for factories such as Gustavsberg, Royal Copenhagen, or even at Saxbo, which is a large studio pottery rather than a factory. What they have done—and they adopted it from the French, in the first place, as we have already seen—is to strive for a pure form appropriate to the industrial background, and based on the Greco-Roman tradition upon which they have hung the new 'ball dresses' from the Orient, that is to say the glazes—and they have made a great study of glazes for stoneware and porcelains. But the forms, as we see it from England, are not really alive and pots without form are like

[1] See, for instance, Nicolas Vergett's article 'Ceramics in the United States', in the *Pottery Quarterly Review of Ceramic Art*, No. 32, Vol. III, Tring, 1966.

bodies without bones. If you look broadly at what has been done, particularly in Denmark, and also in Sweden, you can say: an alliance between the studio and the factory has been achieved, but at a price.

In Italy there is only one potter with a certain degree of contemporary interest: Gamboni.

Germany had a saltglaze tradition from the thirteenth century. The Rhenish saltglaze, Bellarmines (Greybeards), the steins or beer mugs which are still made today. They have not, however, entered into the contemporary stoneware movement with any particular significance.

Let us not forget the Spaniard, Artigas, from Barcelona, who works with Miró. He is a potter, but he does not build on an old tradition. He is a modern trained in Paris. Madoura, in whose studio Picasso worked, does not count as a potter. His is the tail-end of a popular tradition in the South of France, mainly of Italian origin but modernized. The ware is of no interest as ware. Picasso simply manages to express Picasso, grand acrobat that he is.

In Germany or Holland or Belgium the potters might retort to what has been said: Who are you in England to say that we are not in the lead? How can *you* judge what is of a high standard today? The answer is: 'We are looking for a criterion of values in pottery, wherever it emerges, that covers the whole of humanity. The challenge came in this century with the modern movement and the interplay of modern communications.'

I do not like to give the impression, in an attempt to see the picture as a whole, that I am pouring scorn on all but a handful of potters; for when by the force of social change, artisans vanish and the artist-craftsmen take their place, then they will be judged as artists and on an international level. Moreover it is the potters themselves, the people who know, who will be the eventual judges. In the last decade a flood of experimental and ephemeral pots have poured out of studios all over the world. The light material will float away, it is the sediment that matters.

There are revivals in various parts of the world among peoples of a more primitive culture; for instance, Nigeria, where Cardew went and taught for years. Ladiquali is the best-known name, a woman, working in a village tradition on household pottery. She was taken by Michael Cardew into the world of contemporary stoneware. Her pots are a kind of translation of the primitive into the post-industrial, without the native self-discovery of industrialism and all that goes with it, the post-industrial life. Although under the guidance of a good English potter, the result is that her pots are intelligently made but not born. I had a pupil, for instance, an African from Jamaica, who came to work in my pottery, Cecil Baugh, a descendant of slaves. He still was to some extent conscious of and connected with an old primitive African pottery tradition. He worked earnestly, but was unable to enter into the freedom of the modern world with ease.

And Leach, remembering Blake's verses on the black people, declaimed: 'Fly winged thought and broaden their foreheads . . . ' Then he added, 'To stretch from a locality in a primitive state into a sophisticated post-industrial world—for that the thinking is not big enough.'

The Work of Bernard Leach

'The love of work is the basis, and the only basis, for the larger process of all making.'

Bernard Leach in a conversation with the author, 1947.

Bernard Leach went to Japan in 1909 as a draughtsman and etcher, and left it in 1920 as a potter. The incident through which, in 1911, he became a potter by chance—or was it fate?—is delightfully recounted in *A Potter's Book*.[1] That Leach brought with him all the thirst of a novice to produce beautiful things for use in everyday life, in order to embellish it, that he was imbued with eagerness to excel in an old craft, is revealed by the outstanding beauty and quality of his best pots. That it was a living, even human, beauty which he was concerned with may find expression in his own words: 'It is not without reason that important parts of pots should be known as foot, belly, shoulder, neck and lip, or that curve and angle should often be thought of as male or female.' And as a master he told his pupils: 'The ends of lines are important, the middles take care of themselves. Lines are forces and the points at which they change or cross are significant and call for

[1] Faber and Faber, London, 1940. The second edition of 1945 has been reprinted ten times.

emphasis. Vertical lines are of growth, horizontal lines are of rest, diagonal lines are of change. Straight line and curve, square and circle, cube and sphere are the potter's polarities. Curves for beauty, angles for strength. A small foot for grace, a broad one for stability. Enduring forms are full of quiet assurance. Overstatement is worse than understatement. Technique is a means to an end. It is no end in itself.'

Once I spoke admiringly of the unglazed parts of his wares—it was in 1947, on my first visit to his St Ives pottery. He remarked with a smile: 'The warm brown tone which reminds you of a golden biscuit, the natural voice of the material, is achieved by the combination of a high temperature—we bake our ware between 1,300° and 1,350°, the temperature for Japanese and Chinese porcelain respectively —with the composition of clay and the glaze given by wood ashes which are allowed to fall on the ware from the fire in the kiln. You have noticed rightly that the glaze does not cover the whole form in many of my pots and that the natural colour of the body is used as a decorative effect. This has its origin in early Chinese practice. To prevent the glaze running over the edge of the ware and sticking to the support they left the lower part uncovered. The Chinese craftsman, who does not distinguish between aesthetics and utility, saw beauty in the necessity and used it. His natural methods resulted in a good colour and texture.

'The colour of my glazes range from grey, grey-green, occasional quiet blues, to the iron colours, i.e. from rust to black and variations of these. This colour scheme is limited by the high temperature of the kiln. For the glazes I often use vegetable and wood ashes, and we have done much in England to introduce the knowledge of these ashes as fluxing agents in high-temperature glazes.'

As in the beginning of his career, so also lately Bernard Leach has employed for individual pieces other colours than those we have named, amongst them a dark olive-blue stoneware glaze, often in conjunction with the red-brown 'Kaki' glaze as pattern.

Speaking in the summer of 1966 about the phases in his development, a theme which he took up again in a long letter to the author, he sketched it in general lines as follows:

In Japan I saw Raku, the soft earthenware, baked at low temperatures; I produced innumerable pieces. My only teacher as a potter was the Sixth Kenzan, with whom I worked for two years, 1911–13. But, as my master also had a stoneware kiln, I tried my hand at producing some of this, too, and even a few pieces of porcelain, all three of which were decorated and, as I now think, overdecorated. As I look back the pots wriggled with

naturalistic patterns.[1] After three visits to Peking, I eventually returned to Abiko,[2] where old Kenzan's kilns were re-erected for me. There, and in Tokyo later, I continued with Raku, stoneware and porcelain, gaining experience of shape and technique and even essaying enamels on porcelain or semi-porcelain. But it was not until I had returned to England in 1920 and saturated myself in our own lead-glazed traditions of slipware for some ten years that I began to simplify and, I think, to reach the beginning of any true mating of my double inheritance of East and West. I had a flirtation with the saltglaze stoneware of northern European origin, after I became aware of the nobility and sturdiness of our own English medieval earthenware traditions. But I have never carried that as far as I would like to have done. Instead, during the last twenty years, I seem to have concentrated upon the black to rust glaze called Tenmoku, on the one hand, and the pale blue, green porcelain glaze known as Ying Ching on the other. These pots are often plain, but where I have employed decoration, my desire has been to keep it subordinate to material, to technique, and most of all to concepts of formal but living relationship.

Besides the line of technical accomplishment, accompanied as it is by ever-growing kiln temperatures—750° to 1,000° to 1,250° to 1,350°—there is the unfolding of the aesthetic side, the decoration. Behind and beyond the technique of throwing: with Raku it was the tradition of colour used by Kenzan and the decoration by brush; with slipware it was the treatment of skins of liquid clay poured or scraped or engraved or combed on in very intimate relationship to the material clay. The saltglaze is severest, it is hard. What is used is a gas which gradually deposits glaze on the surface of the pot; it is the flow of the chlorine gas over the form in the kiln which produces a thin skin of transparent glass, so that every movement on the surface of the clay and every kind of texture is nakedly exhibited. The coloration is limited and the deposit on the surface forms a skin like orange peel. As the gas attacks the tiny points of silica it produces the chemical combination of salt and silica—which makes the glaze. It is not brushed, it is not dipped, it is not sprayed on. The field of expression in the stoneware coming from both China and, particularly, Japan, is on the other hand limitless, it opens the door wide to every kind of broken texture— quite at the opposite pole to porcelain and industrial ware.

Finally coming to this strange substance called porcelain, he said of it:

White and translucent, smooth, a kind of natural glass, as it might be described, it is a half-melted white translucent stone, so that in high temperatures—both in stoneware and in porcelain—man is re-melting the rock, for china-clay is ex-granite and feldspar is granite too, rocky.[3]

In all these technical processes there are rich opportunities of new expressions, new combinations, effects achieved by potters here and there, an infinite variation, a silent

[1] For Leach's early work see *A Review, 1909–14*, Tokyo, 1914 (privately printed, English and Japanese text), and in *An English Artist in Japan*, Tokyo, 1920 (privately printed, English and Japanese text).

[2] Bernard Leach's workshop in Japan.

[3] Feldspar is a constituent white crystal in granite; China clay is decomposed feldspar.

language of communication between the aspirations of men in different parts of the world. And do not forget. It is a great moment in history—not only for the potter but for humanity—when knowledge is available from every time and every land. Now we have to learn the language which goes beyond eclecticism . . .

As early as 1920, when Leach had left Japan after eleven years, Dr Soetsu Yanagi wrote of him: 'Leach has always been our friend. Few foreigners have been so loved and understood by young Japanese as he, and I do not suppose that there is anyone who has loved young Japan so fervently. . . . Leach was always hard at work, and when he was especially busy he would scarcely stop for meals. . . . I am quite sure he will become known as the creator of some eternal masterpieces. He is fertile in design, possesses a fine discrimination for form and quality, and an intuitive sense of beauty. He has a depth of feeling that goes beyond mere technique, the character of an artist who will be satisfied with nothing short of work that will live.'[1]

The problems that faced Bernard Leach when starting his pottery at St Ives in 1920 were complex. How could the individual potter work and exist against the background of industrialization? What was his moral and artistic function in modern society? How should the relationship of art and life be solved, how the co-operation between master, pupil and apprentice, the employer and employee? Was there a future for the spiritual co-ordination of East and West, for an ideal unity and wholeness towards which he never stopped striving? Could any art and craft worthy of its name exist without a religious foundation in the personal beliefs of its creator? And questions of technique, of form and texture, of decoration and purpose also arose—the merging of the various sources of inspiration into a personal style. All this had to be considered, and so it has been during these fifty-five eventful years in the service of the revival of European pottery.

We have discussed the philosophical and ethical implications connected with his task; let us now concentrate on the work in more detail.

It was in Japan that Bernard Leach began to realize that he was a European and that he did not want to make Japanese or Chinese or Korean pots. He felt the need to know his own roots and studied some books on eighteenth-century English slip-ware, especially Charles J. Lomax's volume *Quaint Old English Pottery*. For the first time he became aware of his heritage in pottery as an Englishman and it made a lasting impression on him. In 1918 he produced a Japanese Raku version of slip-ware, but in 1920, after his return to England, he started to make proper slipware

[1] 'Leach as I Know Him.' Quoted from *An English Artist in Japan*, op. cit.

until the mid-thirties, when he dropped it altogether. The reason was mainly his conviction that a craftsman must move with his own epoch and that harder, stronger wares were more suitable for our modern life. Slipware belongs to the great earthenware family of pottery, being made of very plastic (sticky) clay. It is a modeller's art, therefore dependent on the wheel, warm in character (usually a red clay, often covered with a creamy slip) and homely in colour (brown, red, ivory), suitable for honey, treacle, cream—that is to say for simple country life, the extreme opposite to life in the metropolis. Slipware was highly developed in England and Bernard Leach is of the opinion that the crusaders brought back some of the technique from Egypt. He seems to have found confirmation of this in a collection of fragments of old Cairo pottery in the Victoria and Albert Museum in which he could trace all the 'English techniques'.

The types of wares which Bernard Leach has produced throughout the years are:

Ware	Kiln Temp.	Date	Place
1 Raku	750°	1911–20	Japan (except the time spent in Peking, 1915–17)[1]
2 Stoneware	1,250°–1,300°	1911–20	As above
3 Slipware	1,000°	1920–35	England[2]
4 Stoneware	1,250°–1,350°	1935–66	England
5 Porcelain	1,250°–1,350°	1935–66	England[3]
6 Saltglaze ware	1,250°–1,300°	1935–66	England[4]
7 Enamelled porcelain and stoneware	750°		Japan[5]

The forms and shapes which Bernard Leach produces are finally prescribed by their use: bowls, vases, jars, jugs, mead-jugs and beakers, dishes, plates, pots, tea-pots, coffee-pots, boxes, and tiles. They are individual pieces signed B.L. and

[1] He also produced some Raku between 1920 and 1930 in England.

[2] When, in 1953, he was asked to make some slipware he produced over one hundred pieces which were sent to Japan.

[3] Since about 1955 Leach has produced a pale celadon porcelain inspired by the Ying-Ching ware (the earliest Chinese porcelain of the T'ang Dynasty). But he has also been influenced by the rather opaque and heavier porcelain of the Ri Dynasty in Korea (the later Korean porcelain).

[4] Bernard Leach has made only a comparatively few pieces hitherto and these mainly in conjunction with his wife and partner, Janet Leach.

[5] At the beginning of his career, at Abiko, where he had built his first kiln on Dr Yanagi's property after his stay in Peking, and during his visit in 1954.

marked with the emblem of the St Ives pottery, S.I. The domestic ware (the standard forms) catalogue of the Leach pottery 1959–66 listed sixty-seven items (ovenproof stoneware and hard porcelain), the glazes of which are black to rust, Tenmoku, mottled grey-brown, pale celadon green. This ware is produced collectively, the basic forms being mostly suggested by Bernard Leach himself. The yearly output is up to 22,000 pieces (of which 2,000 are individual) and the aim of the pottery is to produce the best shapes for objects of daily use, i.e. true to material and method of production and so plain as to avoid expense. Some of it is unglazed outside, and Leach has kept to the tradition of unglazed ovenware. Behind the style of this ware stands the fact that the potter-craftsman is in reaction against the industrial world which is the inheritor of eighteenth-century taste, derived from court taste. It had become decadent, artificial, with highly complicated, even bizarre, forms (suitable for plaster-cast making for mass production) and gold and white and enamel coloured decorations.

A group of ten to twelve people, including the apprentices, now work in the St Ives pottery, under the leadership of Bernard Leach. During the past ten years the organization and management has passed largely into the hands of Janet Leach. The foreman is, and has been for years, the Cornish potter William (Bill) Marshall, an outstanding craftsman who learned his craft from Bernard and David Leach and who signs his individual pieces W.M. In addition to wages, the group has a share in the profits. When Bernard Leach initiated this group work he had an ideal notion of its function.

After many years of trials, he now realizes that a fully successful group experiment like his depends either upon a superimposed leadership or upon a common ground of belief. This moment in history, he reasons, is neither one of leadership nor has it a common denominator of belief. So when considering the increasing cost of labour, its successful employment in a unit of co-operation grows less and less practicable. Across the Atlantic therefore we find today more and more individual craftsmen and no employed labour at all. One may say that with the 'new' order, the community of craftsmen (a nineteenth-century ideal) becomes improbable. Bernard Leach ascribes the difficulties he meets in his group experiment to the inherent conflict between artistry and business management. Nevertheless, the long-standing effort of the St Ives pottery is a remarkable achievement. Delaherche, after his stay in Paris, lived the life of a recluse at La Chapelle from 1894, firing his kiln only once a year. Is it an irony that, amidst an ant-heap mentality which modern mechanized society has fostered, the artist-potter can find

only one way out: a hermit-like existence with obligations only to his inner creed and standard?

We spoke before of the impact which Chinese and Korean classical works (Sung, Ri, Korean celadon and the early Japanese teamasters' ware of the seventeenth century; the classic Japanese tea-bowl—influenced by the common rice-bowl of the Ri Dynasty which is known in Japan as *Edo*) made on Bernard Leach. Apart from medieval English earthenware and the English slipware of Thomas and Ralph Toft, Ralph Simpson, and William Taylor, only the best wares of the Ming Dynasty, early Persian, Hispano-Moresque pieces, German Bellarmines, and some Delftware can for him take their place beside the classical Far Eastern examples. The less sophisticated tin-enamelled work from Italy, Holland, and England (fourteenth to nineteenth centuries) has also impressed him; but in contrast to the exclusively 'modern' potter, Bernard Leach is basically an artist rooted in tradition (and what true artist is not?) whose doings are dominated by three imperatives only: the character which the material imposes on the form, the use to which the form is put, and fidelity to his own character. The rest is a question of taste. Bernard Leach's pots are always sound and often beautiful. Apart from their practical function, they fulfil a moral function in the Platonic sense. In *A Potter's Portfolio*,[1] Leach quotes William Morris as saying: 'Every improvement in the standard of work men do is followed swiftly and inevitably by an improvement in the men who do it.' And he says himself: 'One has to live with fine pots in order to appreciate their character, for they are intimate expressions of peoples and their cultures.' It is here that we can find the root of the influence which Bernard Leach, the man and the artist, has exercised on his time. When defining a 'good pot', and posing the question: 'How can we recognize qualities in pots which can be related to values which have already been set store by in life?' he will speak of 'familiar virtues', suggesting something of the way in which the spirit of a culture and the experience of race flow through the focal consciousness of the individual potter. Thus he demands the awareness of the human background behind pots, and this is the essence of his art.

The style which Bernard Leach established in the age-old tradition of pottery-making was the outcome of untiring work, endless trial and error and serious contemplation. His early Raku ware had, stylistically, a curvature of florid character both in form and in decoration. The biggest change from his early to his later work must be seen in a greater severity of form, where the curves are subordinated to

[1] Lund Humphries, London, 1951.

internal thrusts which are straight lines—he likes to use the simile of 'flesh and bones'. In his early days he was much more attracted by brighter colours and of a greater variety (largely the traditional palette of the Kenzans, with the exception of the blue slip). The lower the temperature of the firing the wider the range of colours, for only a few of the metal oxides used for this purpose can withstand high temperatures. Leach's early Raku ware had a creamy-white body and a red ochre or blue cobalt, sometimes a copper green and antimony yellow pigment. The colour was Far Eastern, the form not exclusively Eastern, but influenced to some extent by shapes of European tradition; the decoration was predominantly European, based on folk-art motives. The decorative pattern used for a pot had, for him, to have the same quality as a proverb or a folk tune or a folk dance. To start with it was rather naturalistic, but later he admired Cézanne, Orthon Friesz, and other modern painters. This imposed a simplicity upon his decorations, which finally led even to an abstract patterning.

In his slipware the style of the decoration had an eighteenth-century flavour. Later, in his stoneware and porcelain he turned in the direction of the thirteenth and fourteenth centuries and finally to the seventh to twelfth centuries of the Chinese and Korean tradition. With the production of stoneware and porcelain a change in form and pattern followed almost automatically. The stoneware is rougher, heavier, thicker, and greyer; it is opaque. The lower-temperature ware is more fragile than the stoneware or porcelain. It is a good non-conductor of heat, it is porous, and that in itself stresses the use of the opposite end of the scale. Porcelain is thoroughly vitrified, non-porous, white, hard, and the porcelain body is usually not very plastic. The porcelain which Bernard Leach made was at first translucent only to a certain degree, later on it became thinner. He found by experiment a way to make a satisfactory porcelain body, a technique which has scarcely been developed in England. The bone china discovered in the eighteenth century is a kind of artificial porcelain fired at a lower temperature, and therefore more economical in production, but suitable only for industrial processes and not for throwing on the wheel. Leach, who started to make porcelain in 1912 when working with Kenzan, has produced a few pieces throughout the years, but only about 1950 did he begin to discover how to make a porcelain body which was sufficiently plastic for throwing. For the decoration of his pots he developed a technique of his own, for he could not use the brush in the Oriental way; realizing that he belonged to the tradition of the pen, the pencil, the ball-point and the stylo, he invented a kind of free engraving. The colour runs into an engraved line which darkens it and

then he brushes loosely over it, rather as a pen-and-brush drawing is done. The wide range of colour was replaced by a more restricted one. It is now, as we have already seen, either the Tenmoku black running through rust-red on the one side or a paler or deeper celadon on the other. Some dull blue and some dark brown patterns painted on a creamy body are also typical of his decorations. And so is the red-brown pattern on a dark olive-blue glaze.

As to the nature of the technique for his decorations, these are either:

Brushwork over or under glaze in a rather formal interplay—sometimes it is just a striping—attempting to keep within the domination of the form, that is to say letting the form determine the decoration. This pigment painting is usually in dull blue and rust-brown.

The *sgraffito* technique of decoration in which the artist uses the methods of engraving, in other words cutting through a surface—skin—of one coloured slip which is laid over a differently coloured body.

The *wax-resistant* method. One glaze is applied to the biscuit, a wax pattern is painted on it and the body is then dipped into another glaze.

The use of *inlaid clays*. A half-dry pot is either stamped, scratched or carved, then another clay is put over it and the surface scraped off so that the clay is inlaid in the incised lines or shapes. Usually white on a grey body.

Bernard Leach has retained to a great extent the *figurative motif*, such as a bird, a fish, a hare, or a calligraphic tree drawing—a willow or a symbol of the Tree of Life, a mountain, a human figure, or a combination of these.

Sometimes the knob on the lid of a pot is in the form of an animal (a frog, for instance), sometimes decorations in relief are applied.

Let us finally say a few words about the weight and the size of pots as applied by Bernard Leach. The question is: Should a pot be heavy or light? A stoneware pot can rarely be compared with fine porcelain, owing to the different character of the materials. Vases, decorative pots or bowls can be heavy: it is advantageous if they are, because then they cannot be easily upset. A teapot, however, which is heavy (or rough) does not fulfil its function properly. There is also another point to be considered. Town life is refined, country life simple, and it is in country life that pottery is rooted, though it can, of course, reach a great refinement, 'exhaling gently an elusive spirit of austere nobility', as we can see in the classic period of Chinese and Korean pottery. As far as sizes are concerned, Bernard Leach has never produced unusually big pieces. The maximum size in porcelain during the last ten years has generally been 12 inches in height or width. The slipware is up to

15 inches. The stoneware is made in all sizes, the maximum during the last twenty years being up to 18 inches high and 15 inches wide.

As we can see from the chart of his development, the work of Bernard Leach has become simpler, more spiritualized and essential—and consequently grander—during the past twenty-five years. He has produced at least 25,000 individual pieces, of which about 3,000 are in Japan and the rest in Britain. When he was asked in 1966 to make sixteen large jars for the new County Hall in Truro—his first public commission—he produced, in fact, what can be called his first monumental work.[1] Lately he has experimented a great deal both with forms and with décors. Always searching for the concept of 'the pot seen as a whole', he has been gradually leaving out the unnecessary in shape, decoration, and colour, and so his work has developed in the opposite direction to eighteenth- and nineteenth-century taste. He has been a seeker after truth rather than pleasure; he has tried to fulfil the demands of humility, dignity, and quietude in the sense of Zen or Tao, which are contemplative, austere, and serene.

<div align="right">J. P. HODIN</div>

[1] The height is 18 inches.

Pottery Drawings and Patterns

I have drawn since I was a child of 6. At 16 I was sent to the Slade; there I suffered under the scalpel of Henry Tonks. He said I might draw one day.

Drawing developing out of script, either with the hard point of the West or the soft brush of the East: drawing as the shorthand of ideas of form, brief and evocative, an end in itself, containing its own disciplines, not tied to the pedantry of mere factual observations—Michelangelo, Leonardo, Rembrandt, Blake, John, Rodin, Lautrec, and then the calligraphers of China, Korea, and Japan.

Thus I came to pottery at the age of 23, and naturally began to jot down the shapes of pots as they appeared ever increasingly to my mind's eye with experience of the possibilities of wheel-thrown shape. Following upon form, the question of pattern arose. Isolated elements of decoration, or repetitive, rhythmic orchestration of empty spaces on pots.

Training as an artist, as well as pottery tradition, inclined me in early days towards a continuance of what I already knew in the new medium of expression. It was only later in life that I began to trust the greater austerities of plain form, texture of clay, and the limited colour range of high-temperatue glazes.

Nevertheless, I have always been surprised that so few potters make use of draw-

ing and, as far as I know none, save Tomimoto in Japan, and myself, of any latent faculty for pattern-making. Pattern in pre-industrial times, all over the world, sprang, like folk-dance, song, and melody, out of the life and belief of simple people, close to nature, in the countryside.

The fact is that people are ceasing to be naïve. Education has altered the balance between action following from feeling and from intellectual thought, and one of the casualties has been the capacity to make patterns. But it might well have been expected that an ability to draw would be of great use to a studio-potter. I have always found it so myself. Ideas come by day, by night, and at all sorts of odd moments, and I keep a drawer full of scraps of paper, backs of envelopes, even newspaper, on which I have jotted down these thoughts before they vanish into thin air. I turn them over every so often, destroying those which no longer speak to me with a sufficient sense of life, and adding others. Constantly I find solutions to problems of shape or pattern, or of technique, which I could not solve ten, twenty, or even forty years back—a better lid to a jar—a better handle to a jug—a further simplification—and in this way preserve a continuity in my work. I believe also that this procedure sharpens self-critical faculties in an objective way. I do not always make pots from prior drawings, sometimes ideas flow while the wheel turns, or when the slip-trailer, or brush, or comb, is in my hand, but one forgets so much without the notation, themes get blurred in the memory. My plea for use of free, fast drawing in connexion with pots is as a time-saver, and for the sake of clarity. Just as a painter makes preliminary compositional sketches, either in black and white, or as Constable did with a brush—usually more lively than the finished picture—or a sculptor makes a maquette, so the potter today would, I feel, be well advised to follow a parallel course.

In this century for the first time in history, with the spread of communications and knowledge, he inherits all the pots that man has made and he is forced to become eclectic, and to that extent an artist-potter.

With this in mind such shorthand drawings are one step out of the world of imagination into the clay of actuality, conceived in joy, and born in labour. Here, then, are some of my graphs of discovery.

B.L.

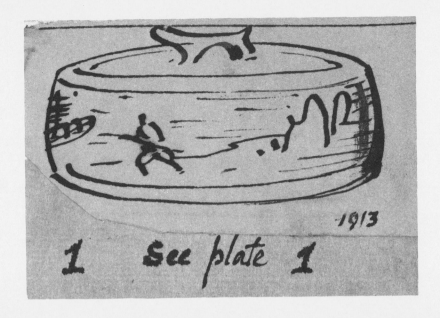

1 See plate 1

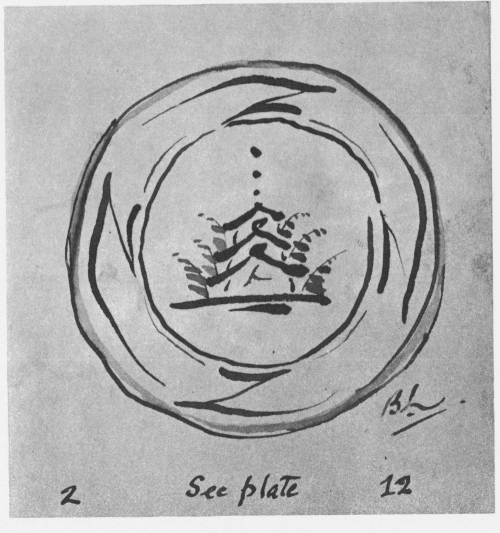

2 See plate 12

No 3 1924

fruit. velure porcelain 1922
No 4

Biscuit jars

Nº 5
mountain pattern 1926

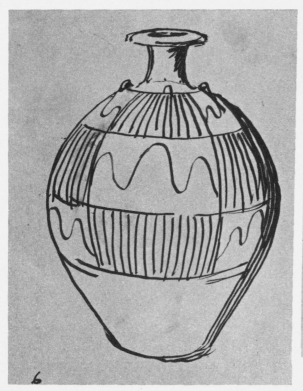

6

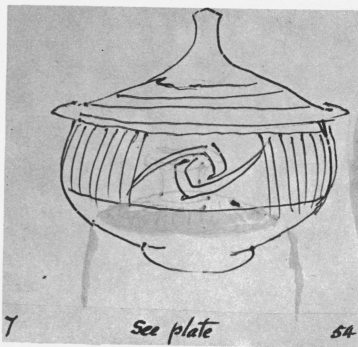

7 *See plate* 54

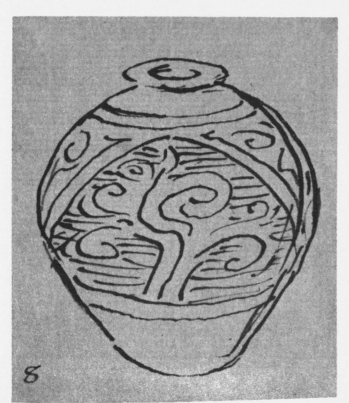

8

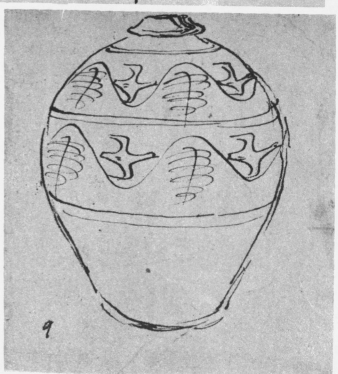

9

Nº 10 Coffee

Nº 11 Tea

Nº 12

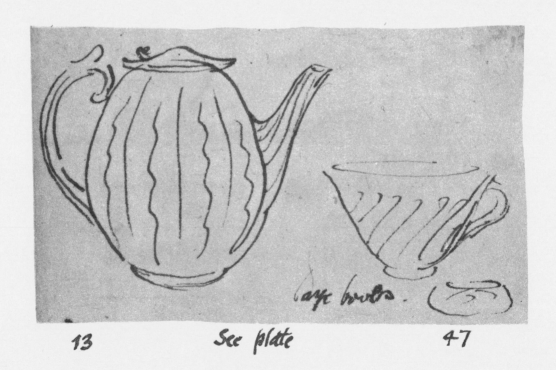

13 See plate 47

14

15

16

17

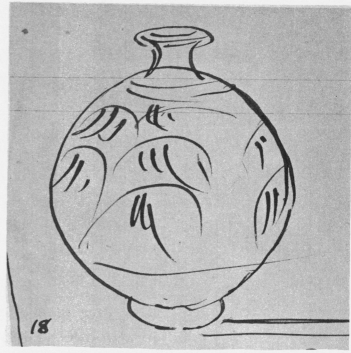

18

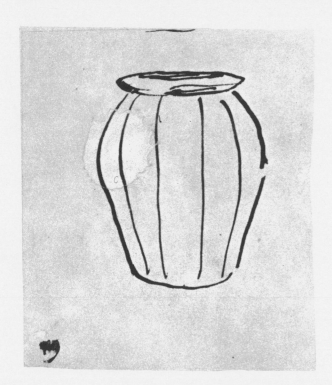

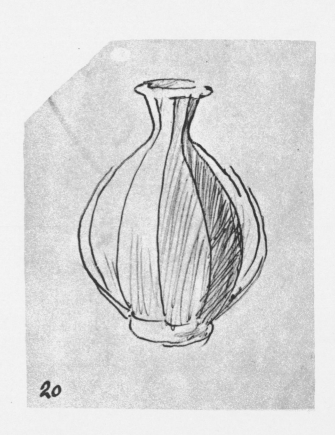

20

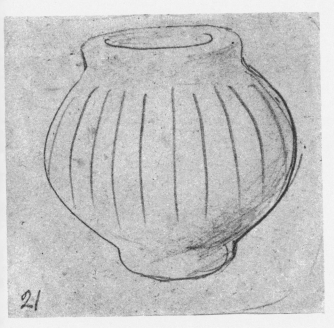

21

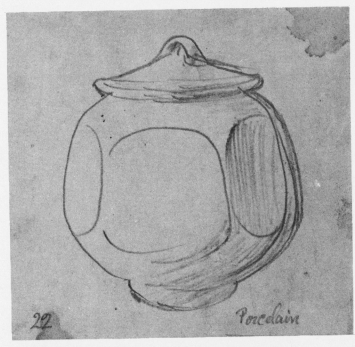

22

Porcelain

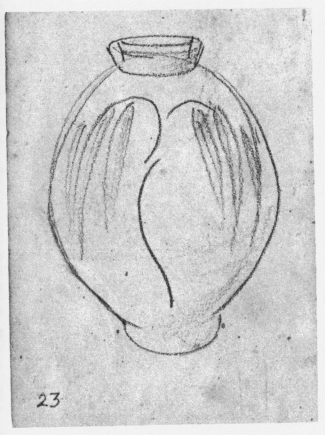

23

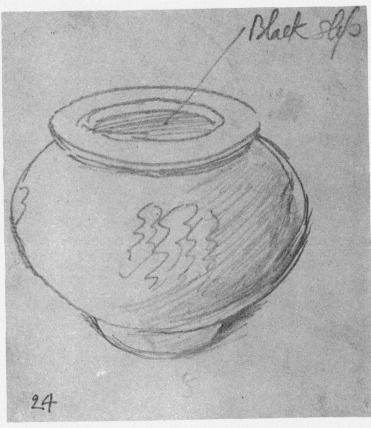

Black Slip

24

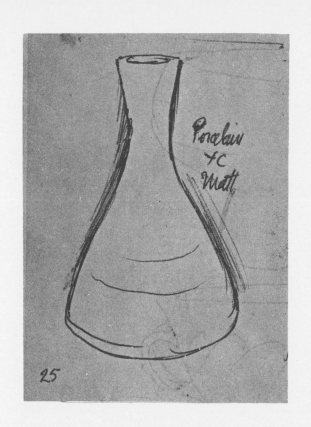

Porcelain
+c
Matt

25

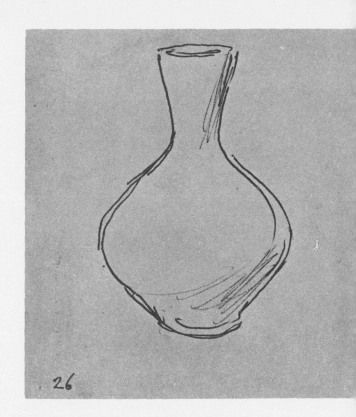

26

Blacks. out & white in
or vice versa.

27

28

29

30 30a

Powder buff

Celadon

31

32

33

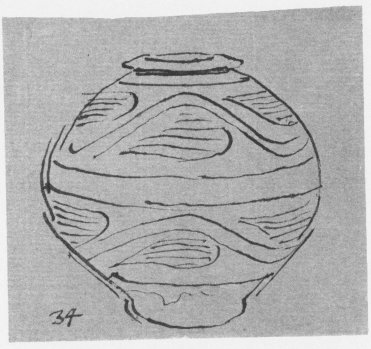

34

38

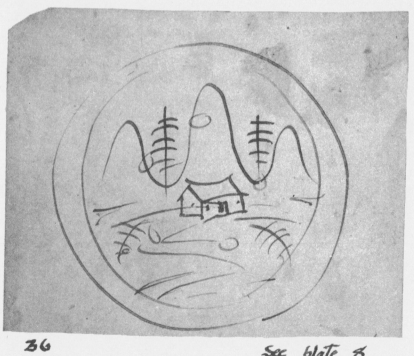

36

See plate 8

37

38

40

41

42

43

44

45

46

47

48

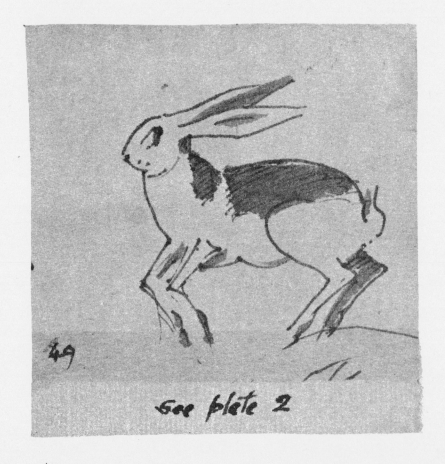

49

see plate 2

50

51

52

53

54

55

56

57 Snipe

58 Plate 26

59

60

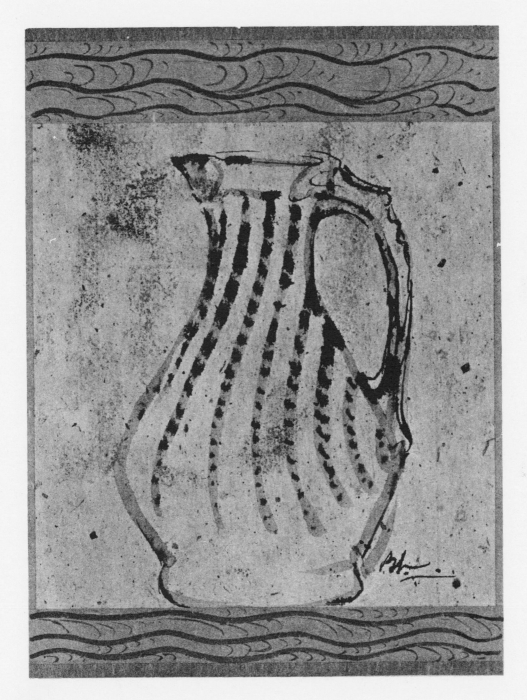

61

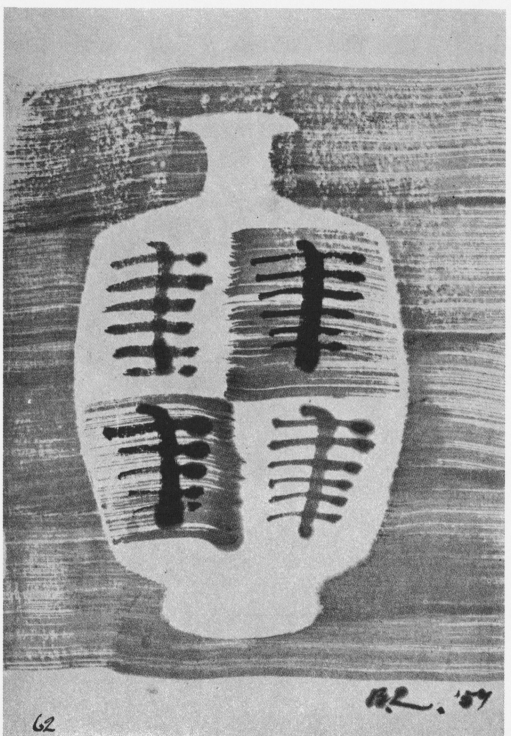

62

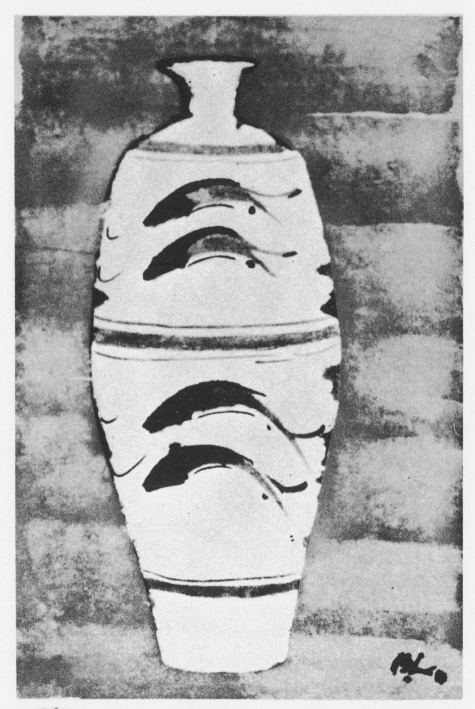

63

illustrations of pottery

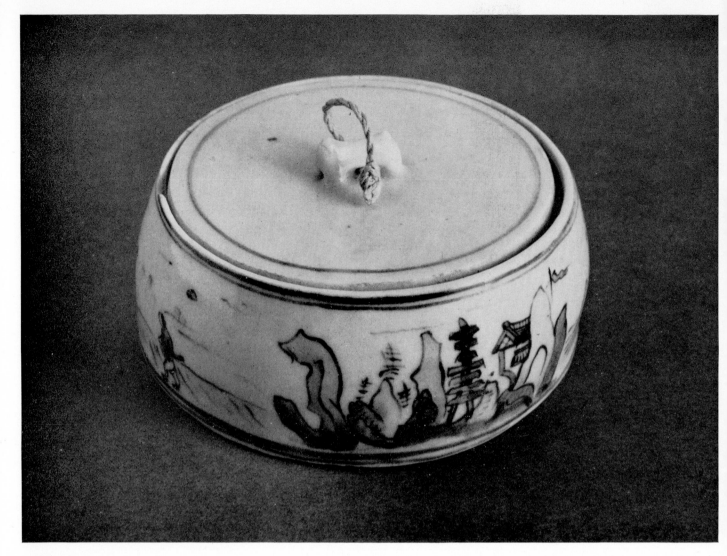

1 Covered Porcelain Pot 4 × 2 in.

I made this blue and white piece in the sixth Kenzan's kiln in Tokyo, two years after I commenced potting. As yet I had not found any idiom of my own and this was an exercise in copying from memory a Chinese example of the Ming Dynasty which I had seen in the Tokyo Museum. When I could not remember details I invented them.

I have made very few direct copies, for early in life I discovered Blake's adage:

'Drive your cart and horse
Over the bones of the dead.'

In the Leach Pottery permanent collection, 1913

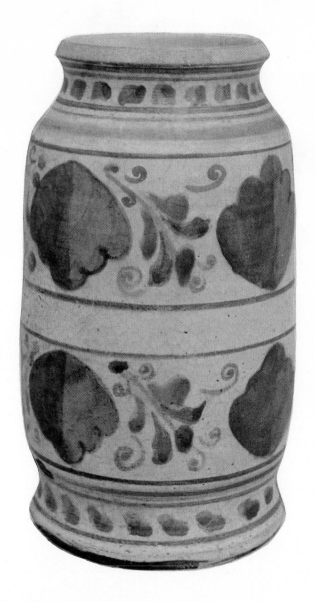

I **Raku Ware Jar** Height 10 in.

This pot was made by me in my Master's kiln in Tokyo as early as 1912. I
copied a Delft drug pot which had probably been brought to Japan in the
seventeenth century. I had not yet found my own feet as a potter, but I
was evidently looking over my shoulder to see what European potters had
done in the past, whilst going through my studentship in Japan. 'Playing
the seditious ape' as Robert Louis Stevenson called it. *In the Leach Pottery
permanent collection. Made in Tokyo,* 1912

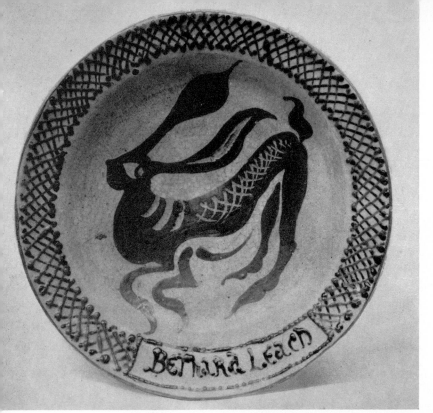

2 Large Raku Plate Diameter 16 in.

This 'Hare' dish was made by me at Abiko, near Tokyo, in soft 'raku' ware. At this time I had not seen the English slip-ware technique of the eighteenth century. My friend, the late Dr Yanagi, with whom I was living, had a book however, illustrating our pre-industrial earthenware—Lomax's *Quaint Old English Pottery*—which spoke to me with the warmth of blood relationship. So I set to work with a fresh impetus from home, in a technique which I knew, attempting to express something born rather than studied. *In the National Craft Museum, Tokyo. Japan*, 1919

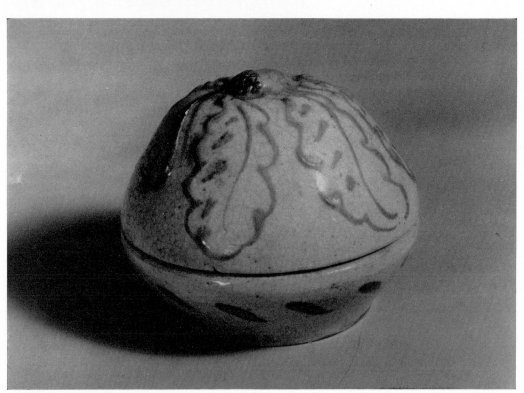

3 Covered Raku Pot $4 \times 3\frac{1}{2}$ in.

This covered incense container was made at Abiko, near Tokyo, when I lived with Dr Yanagi, the founder of the Japanese Craft Movement. The oak-leaf pattern was trailed in ochre over a white body and a little pale copper green was added. *In the National Craft Museum, Tokyo. Japan*, 1919

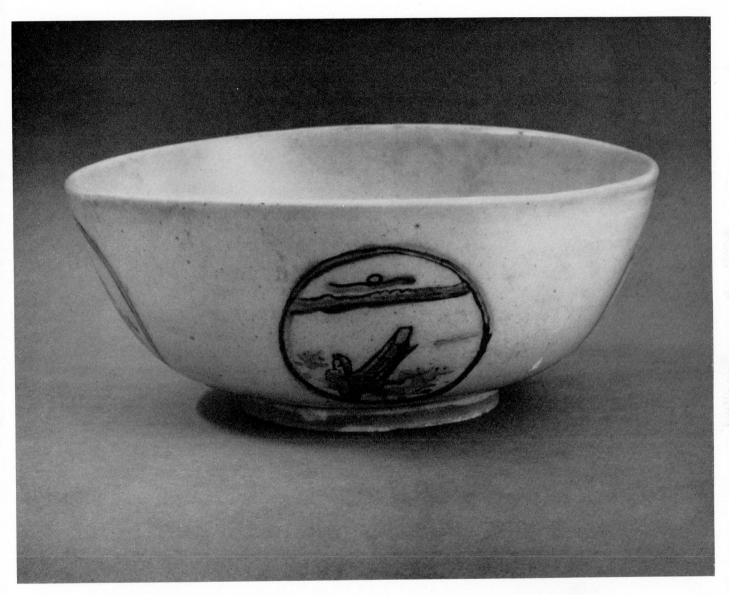

4 Stoneware Bowl Diameter 10 in.

In the circles painted in black and blue-green enamels round the sides of the bowl, are depicted the lagoon which reached towards the setting sun, a fisherman on a punt, and ducks swimming amongst reeds. It was a memento of a very happy year at the close of which my small pottery in Abiko was accidentally burnt down one night whilst we slept, exhausted, after a firing. *In the National Craft Museum, Tokyo. Made in Abiko, Japan,* 1919

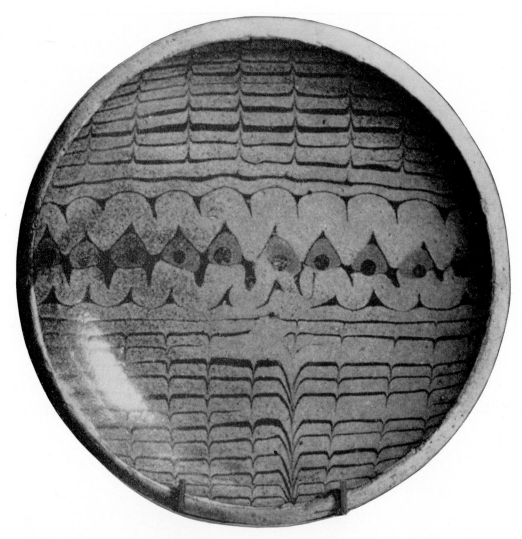

5 Slipware Plate Diameter 9 in.

The method employed in this plate was to pour black slip all over a slice of flat clay. White and red slip were trailed over it before the black had set, then the board on which the clay was supported was bumped sharply down. This caused the superimposed slips to spread without actually touching. After that a sharpened flexible quill was lightly drawn through the surface, producing the effect called 'feathering'. When the surface had dried sufficiently the whole slice was pressed over a hump-mould, centred on a banding wheel, and the irregular edge was trimmed off. *The Leach Pottery permanent collection. Made at Dartington, 1933*

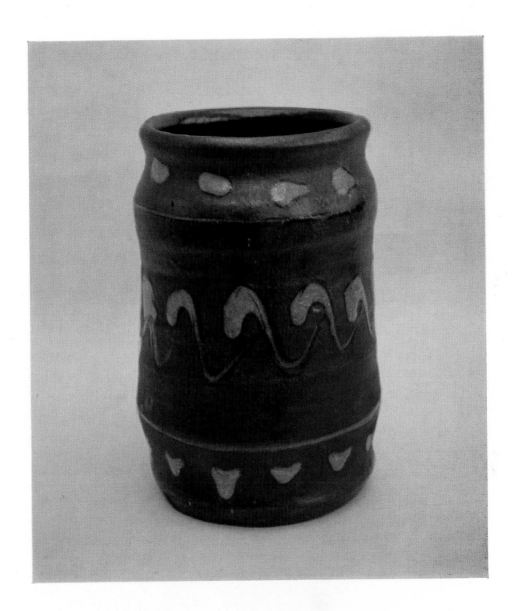

II **Slipware Vase** Height 9 in.

Twenty years later I was still engaged with the same basic traditional European shape, as in Plate I, but in the meantime had re-discovered much of the English slipware technique and applied it with a slip-trailer more freely. White slip over black, under a transparent orange glaze. *In the Leach Pottery permanent collection. Made at Dartington, 1932*

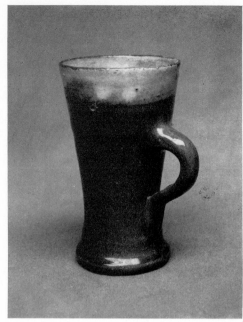

6 **Handled Slipware Beaker** Height 4 in.
Made at St Ives during the nineteen-twenties.

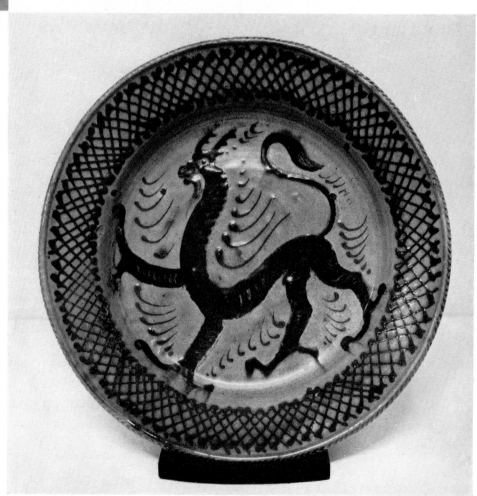

7 **Slipware Dish, 'Dragon'**
 Diameter 18 in.
This strange beast done in the eighteenth-century technique, can barely claim Oriental parentage. *In the collection of George Wingfield Digby, Esq. Made at St Ives*, 1929

8 **Slipware Plate, 'The Mountains'** Diameter 17 in.

I made a number of such decorative plates suggested, in the first place, by eighteenth-century English Toft ware. The pattern in this case evolved slowly, partly from drawings which I made among the Japanese Alps, and partly from mountain patterns on Chinese export wares from Swatow, made in the sixteenth century. *In the Truro Museum. Made at St Ives*, 1929

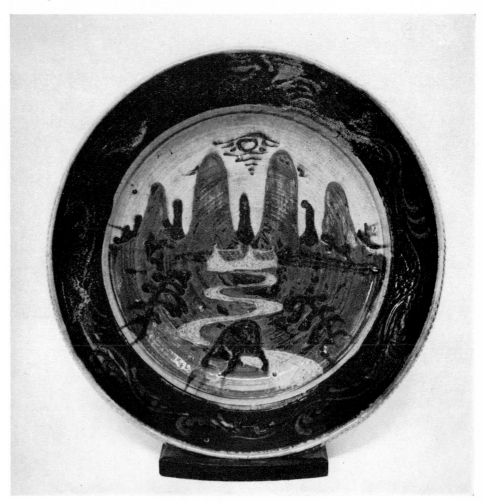

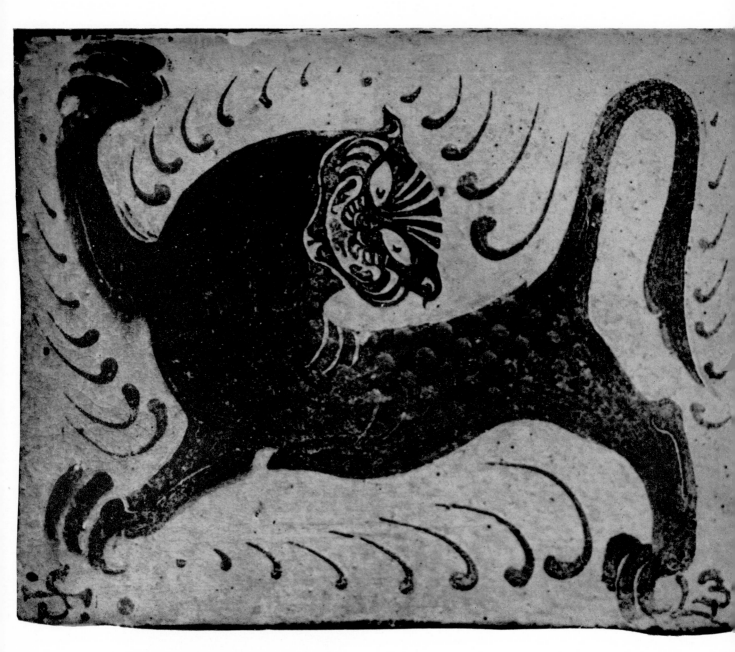

9 **Slipware Tile** 12 × 8 in.

This heraldic lioness was painted and trailed in red and black slip, and in parts engraved, under transparent lead glaze. *Made at St Ives*, 1928

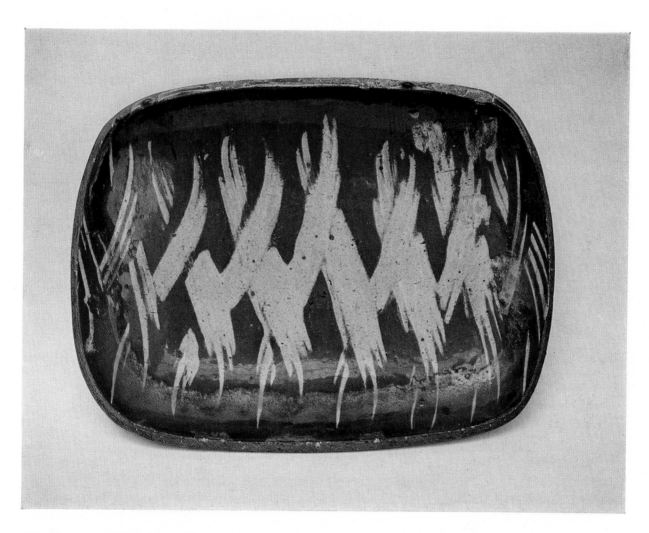

III **Slipware Dish** 14 × 11 in.

This dish was made by pressing a slice of clay on a hump mould, trimming the edge, pouring yellow ochre slip over the inside when the clay was half-hardened, and immediately combing the surface, back and forth, with a notched kidney rubber. *In the Leach Pottery permanent collection. Made at St Ives about 1950.*

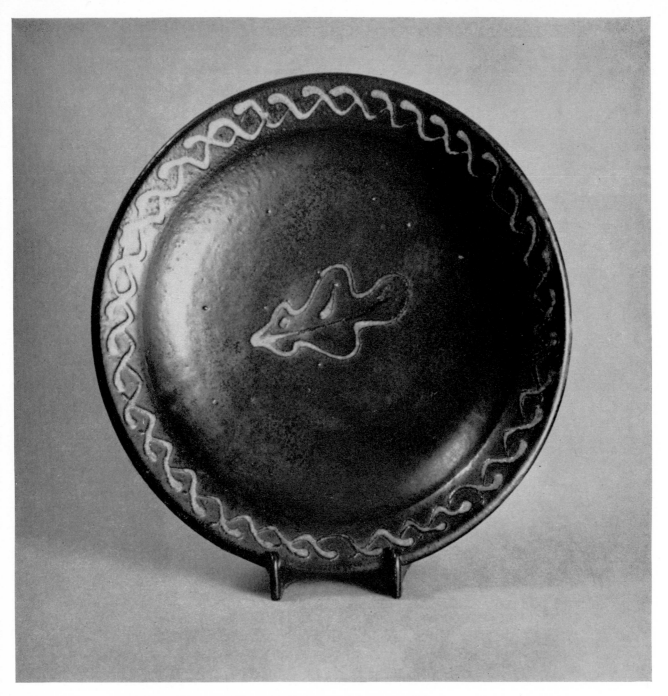

10 Black Slipware Plate, 'Oak Leaf' Diameter 10 in.

When I returned to England from the Far East in 1920 with Hamada and settled in St Ives in Cornwall, we began to try and rediscover the technique of eighteenth-century lead-glazed slipware. We collected fragments of 'combed' oven dishes from the fields surrounding the pottery, and discussed them round our tea-table in front of an open log fire on many an evening, and by putting two and two together we gradually recovered about 80 per cent of the old methods.

In this example white slip has been trailed over a black slip, and the whole plate covered with an amber-coloured transparent lead glaze. *In the Leach Pottery permanent collection. Made at Dartington, 1933*

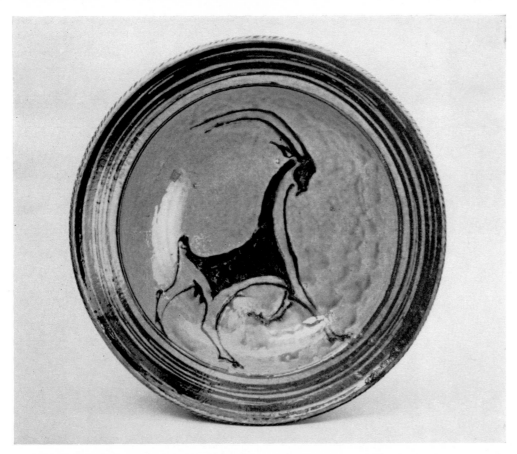

11 Slipware Plate Diameter 20 in.

A large lead glazed slipware dish with a pattern of a mountain goat trailed in black.
This was made at Fujina, near Matsue, in Japan, 1954

12 Slipware Bowl, 'Mountain and Pagoda' Diameter 16 in.

I made this and many other pieces at the Fujina Pottery, Matsue, where there is an old tradition of lead glazing, which, in this century, has been influenced by English lead glazed slipware through Hamada and myself. *In the National Craft Museum, Tokyo. Made in Japan,* 1934

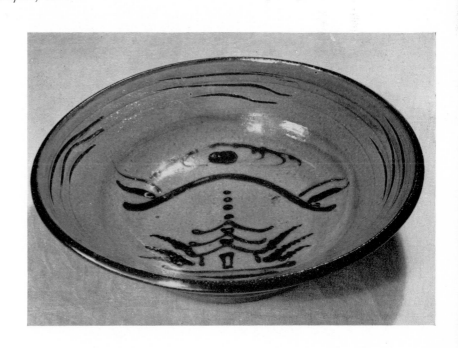

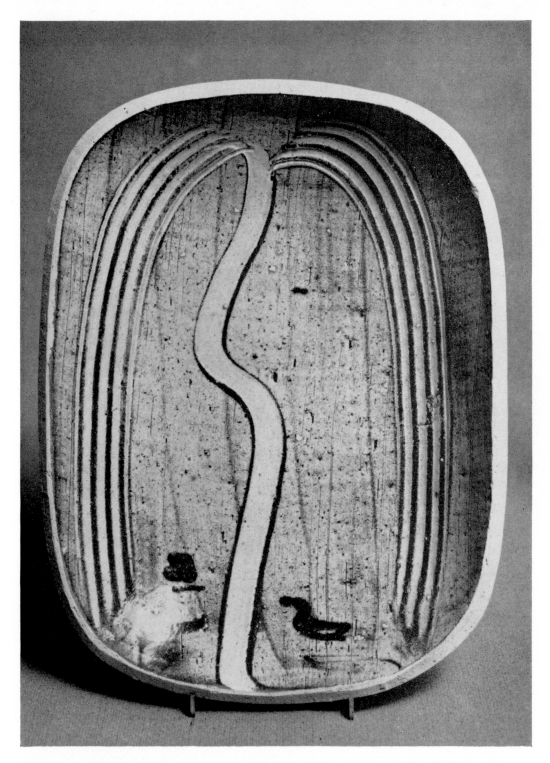

13 Slipware Dish Length 16 in.

Slipware oven dish of white clay made over a hump mould. The willow pattern combed through a coating of yellow ochre, with ducks trailed in black slip. The wave movement of the tree trunk contrasts with the straight parallels of the branches in three movements. *In the National Craft Museum, Tokyo. Made at St Ives*, 1953

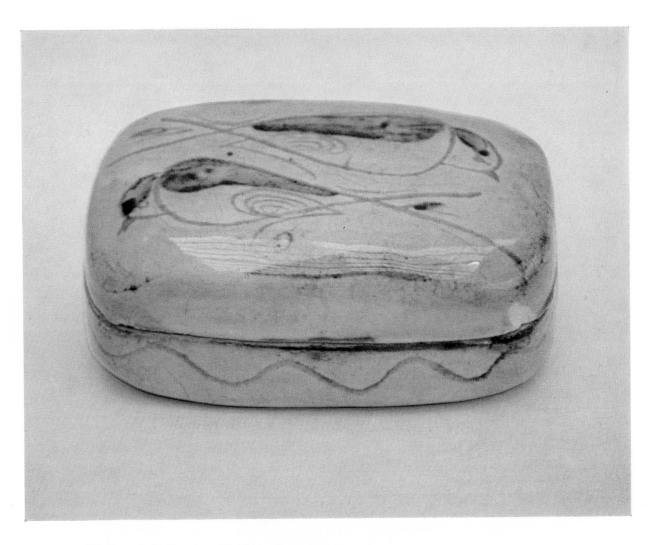

IV **Porcelain Incense Holder** Length 5 in.

This pot was made in press moulds. The semi-hardened body was engraved and then washed all over with weak Chinese cobalt, and the darker tones brushed in. The effect obtained derives from pen and wash drawing. *In the Leach Pottery permanent collection. Made in Kyoto in* 1934

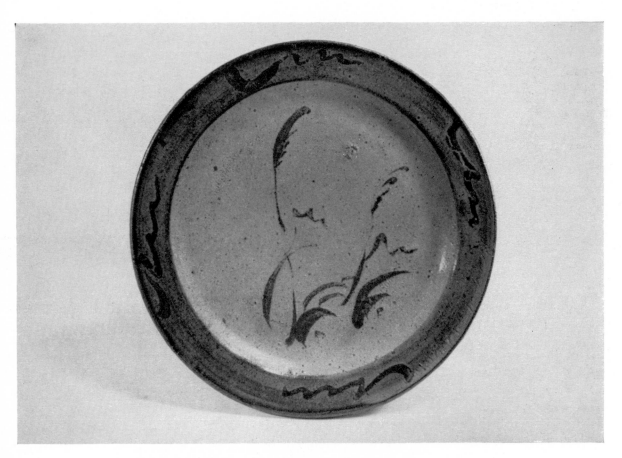

14 **Stoneware Plate, 'Autumn Grass'** Diameter 9 in.

This plate was made and fired in Hamada's pottery. Many people assume that my pots are strongly influenced by Japanese wares. This is not true. Of all the patterns I have made, this is one of the very few which owe a debt to Japan. To China and Korea—yes— but to Japan, very little. I have, for example, never done a single pot in the Kenzan style. *In the National Craft Museum, Tokyo. Made in Japan, 1935*

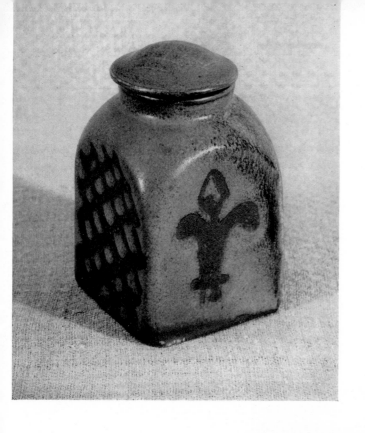

15 **Stoneware Tea-caddy** Height 6 in.
A thick opaque olive-grey glaze over a wax
resist pattern. *In the York City Art Gallery.
Made at St Ives in the late nineteen-twenties*

16 **Stoneware Jar** Height 9 in.
The freckle of wood ash which has
fallen on this open fired jar at the
end of the stoking, has, I feel,
improved the glaze. The effect is
not too glossy and smooth. The
word 'stoneware' suggests the re-
melting of stones, of rocks, and of
clay, which is actually what takes
place at high temperature. *Belong-
ing to Leonard Elmhurst, Esq.
Made at St Ives, 1935*

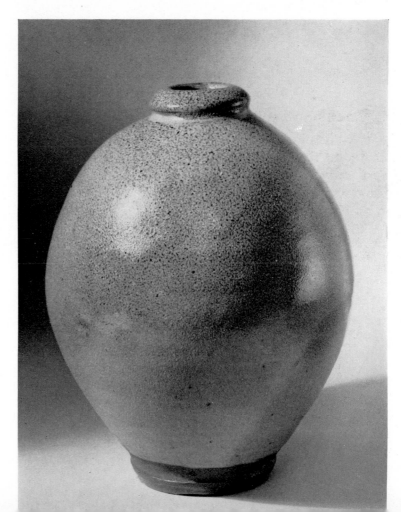

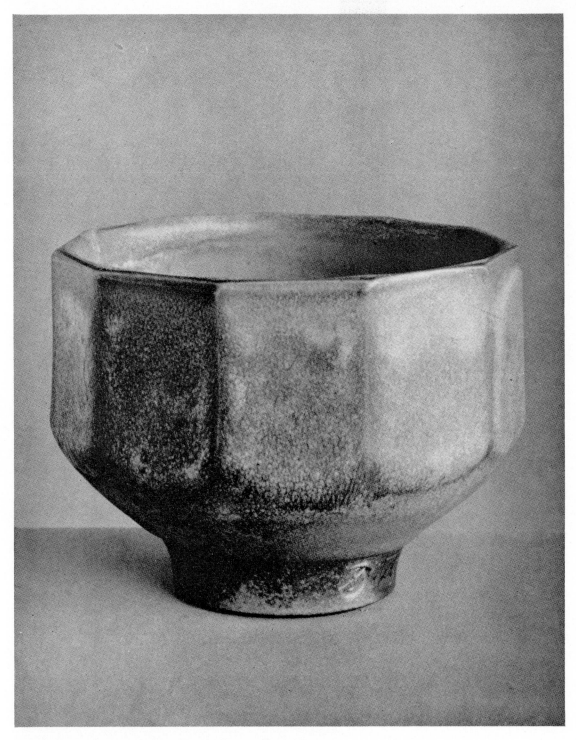

17 Stoneware Bowl Diameter 8 in.

I like this cut-sided pot as well as anything I have made. I was helped by the kiln: we were using some railway sleeper wood as fuel, not knowing that it contained salt-peter for preservation, and although many pots were thereby ruined, a few, including this one glazed with celadon, came out with a matted surface and pleasant, warm discoloration. *In the Victoria and Albert Museum, London. Made at St Ives, 1932*

18 Stoneware Group

Slab, or slice-built cigarette box with a snail 4 × 5 in. modelled on the lid. Blue and rust pigments on grey. Stoneware cream jug. Rust on olive. Height 4 in. *Made at St Ives*, 1935

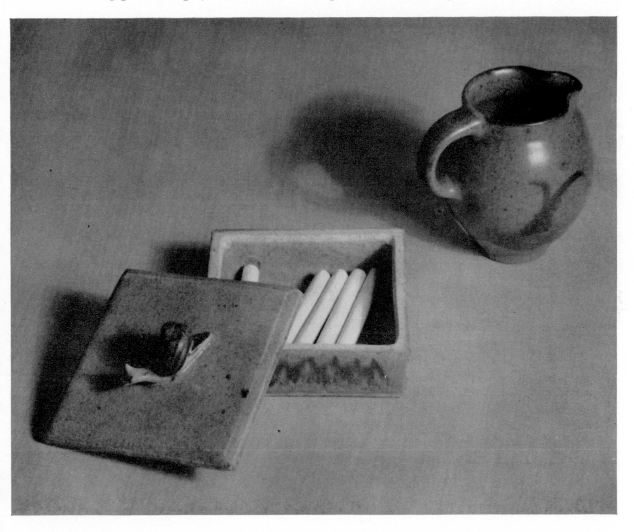

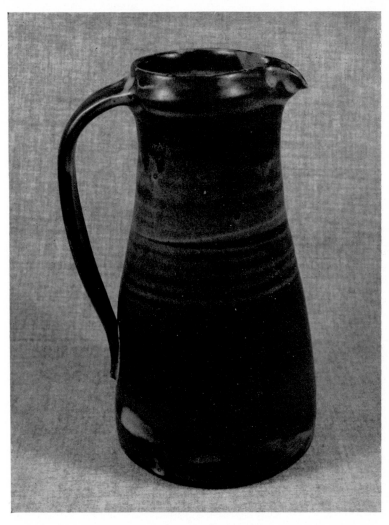

19 Stoneware Pitcher Height 10 in.

This jug, influenced by medieval English form, was the prototype of one of our standard shapes still being produced. *Made at St Ives between* 1930 *and* 1940

20 Stoneware Jug Height 13 in.

The appearance of a thin freckled glaze on the outside of this tall jug is due to the melting of flying wood ashes on to the exposed clay. The pot has been toasted to a burnt brown. *Belonging to Mrs Lucie Rie. Made at St Ives about* 1950

V Tall Engraved Stoneware Jar (OPPOSITE) Height 14 in.

The running glaze on this piece is composed of equal parts of clay and hard-wood ash and was first discovered by the Chinese before the time of Christ. The shape, although unlike any medieval pot I have seen, is nevertheless influenced by our noble English tradition. *Made at St Ives,* 1966

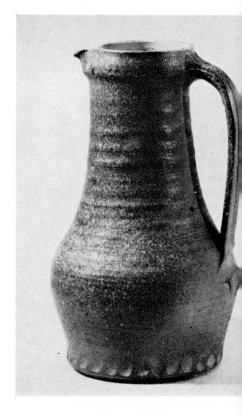

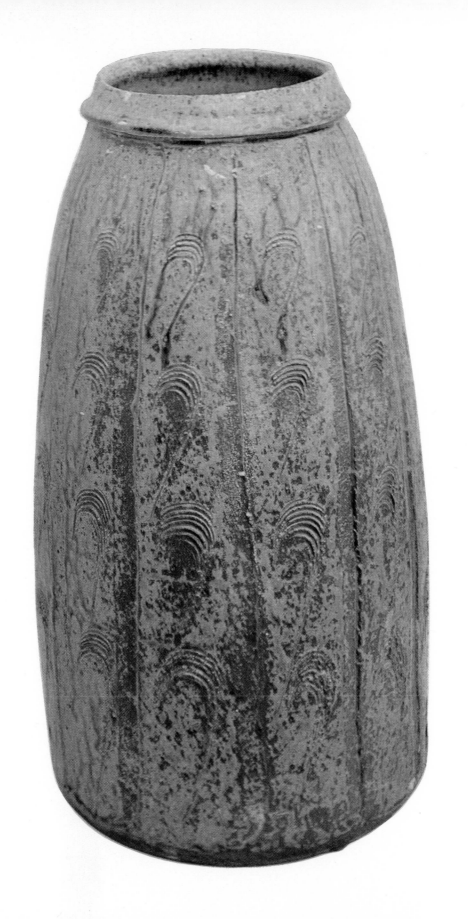

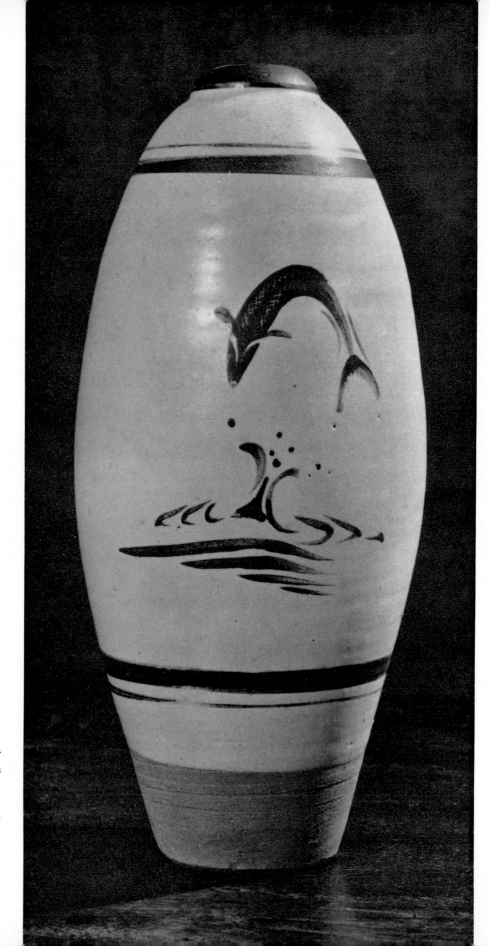

21 Stoneware Bottle
 Height 12 in.

The late Dean of York was for
many years a keen and generous
supporter of young English potters.
Of my pieces this was his favourite.
He left his collection to South-
ampton and York Art Galleries.
Made at St Ives, 1940

22 Stoneware Bottle-Vase Height 9 in.

This stoneware bottle-vase was dipped in white slip, combed and then brushed with iron pigment. *Made at St Ives*, 1961

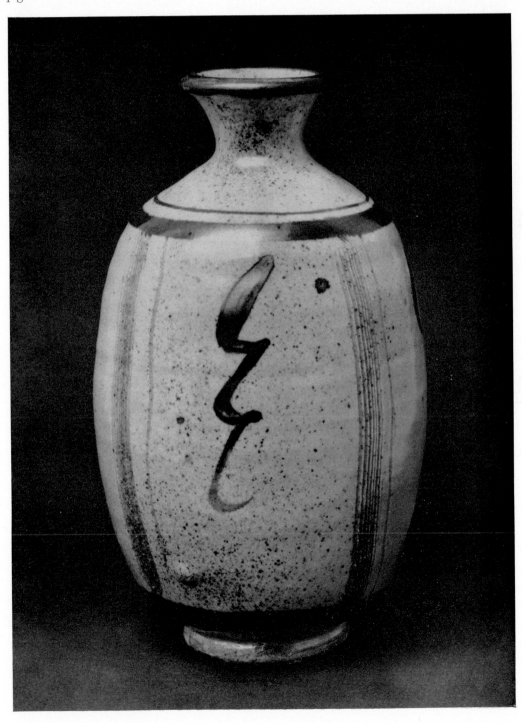

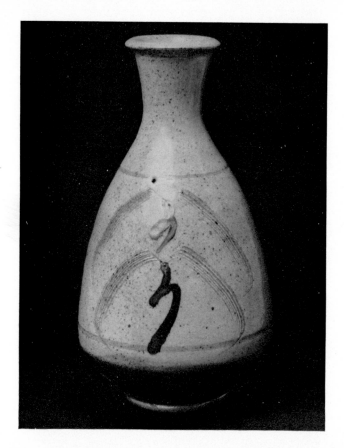

23 Stoneware Bottle-Vase Height 10 in.

In this example the combing of the willow motif is diagonal and is held together by border lines above and below. The element of pattern has been subordinated to the demand of shape, clay and tool. *Made at St Ives*, 1961

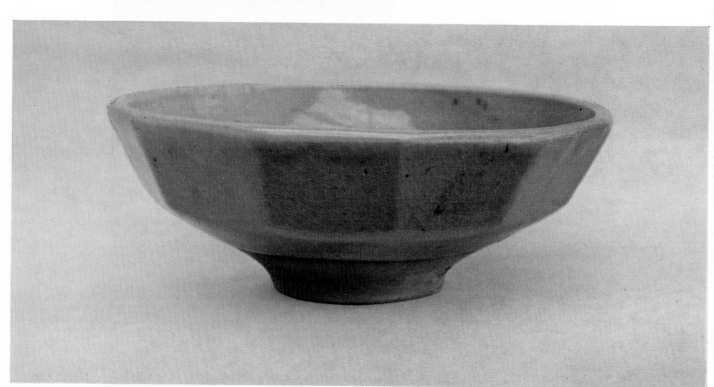

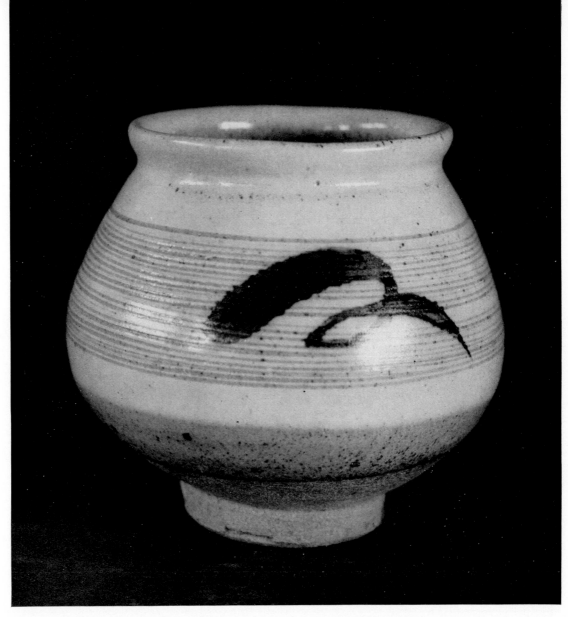

24 Stoneware Vase Diameter 7 in.

This vase was dipped so far in white slip, combed, and then brushed with a rusty iron pigment in one movement. The simplicity of the process has, I think, added spontaneity to the pot. *Made at St Ives*, 1962

VI Cut-sided Celadon Bowl Width 12 in.

The glaze employed in this example is rather of the type used during the Ming Dynasty in China and contrasts with the reddish exposed clay of the foot in the manner I had hoped for. *In the Leach Pottery permanent collection. Made at St Ives, about* 1950

25 **Stoneware Bowl** Diameter 13 in.
The lines are *sgraffito* through white
slip but the curious dotted background
was done on the cheese-hard surface
with the wrong end of a Japanese brush.
Made at St Ives, 1965

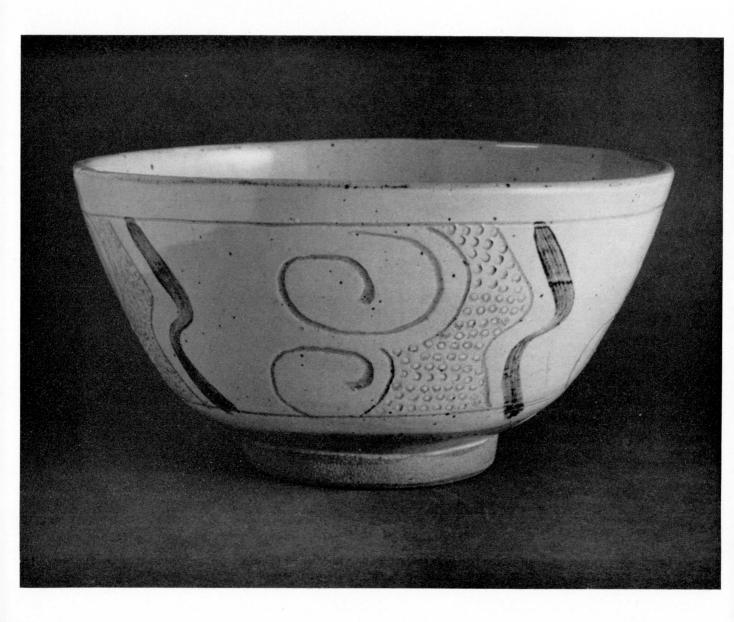

26 Stoneware Bowl About 12 in. diameter

The motif of the internal decoration of this bowl was the memory of a Korean woman beating her washing in the rocky bed of a stream. For the centre I cut a round paper stencil of the figure, stuck it to the leather-hard clay, sluiced white slip over the inside, picked off the stencil, engraved the waves and added the leafage and details in iron pigment with a brush. Oxidized firing. *Made at St Ives*, 1936

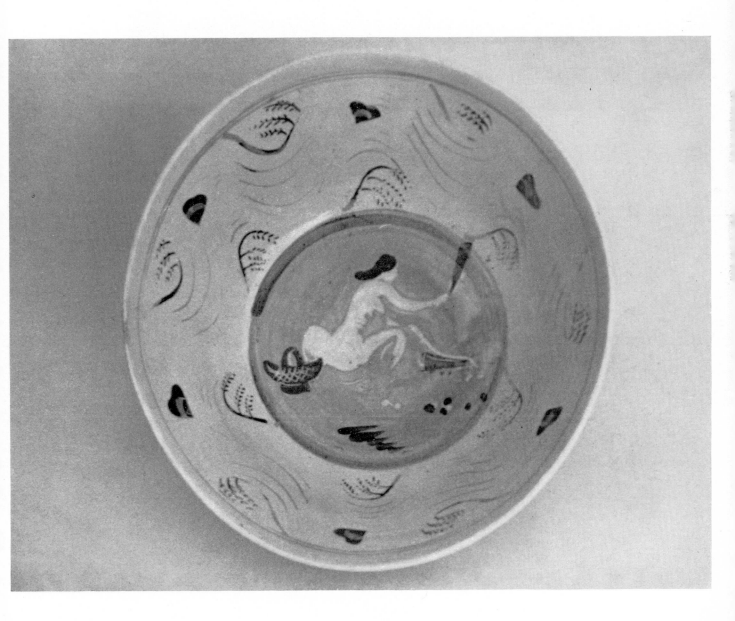

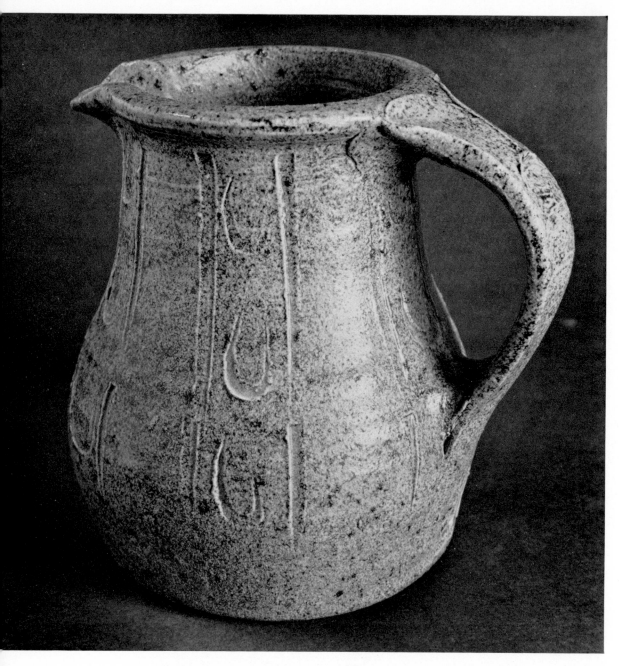

27 Salt-Glaze Stoneware Jug Height 7 in.

Glazing pots by the action of salt fumes on the silica in the clay at high tempera-
ture was a thirteenth century German discovery which spread across northern
Europe. The raw unglazed wares are packed openly into the kiln and when a
temperature of about 1250°C is reached rock salt is thrown into the furnace. The
burning gas combines with the silica, forming a thin skin of glass, or glaze, over
everything. The surface is usually orange-skin in texture. *Made at St Ives*, 1959

VII **Stoneware Pilgrim Bottle** Height 15 in.

The single glaze on this pot is of the family called 'Tenmoku'. The variation in colour between black and rust is simply due to its thickness. Where the glaze is thin it comes out red if there is a clear flame in the kiln at the end of the firing of the kiln. Flattened pilgrim bottles were made in England, as well as in China and Korea, in early times, and for the same purpose of carrying liquids on horse, mule, or, in the East, on camel back as well. My modern version was made for its own sake. *In the Leach Pottery permanent collection. Made at St Ives, 1955*

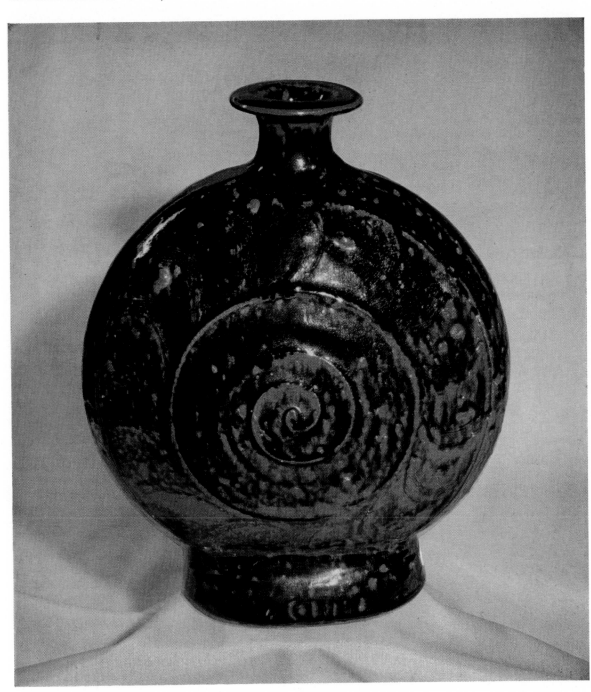

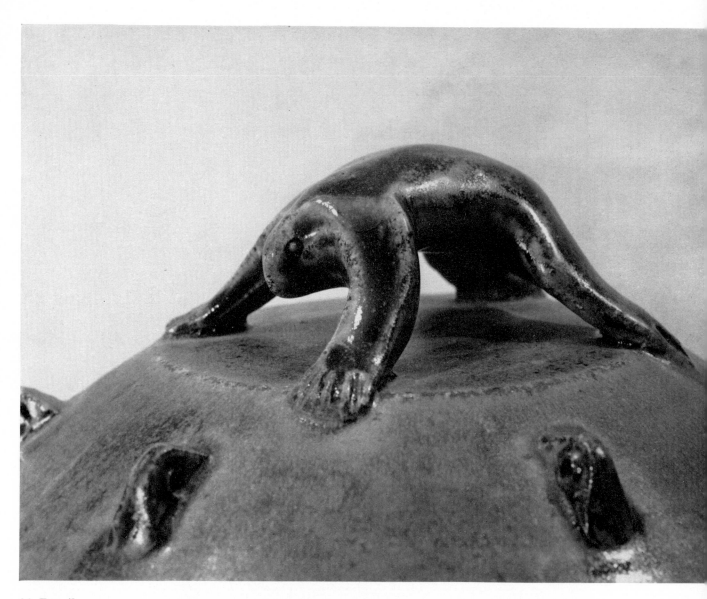

28 Detail

Detail of a large covered stoneware pot, actual size. The knob, or handle, is in the form of some pre-historic animal emerging from primordial slime. Occasionally I have ventured a little beyond the strictly potter's field. The semi-mat glaze was an autumn leaf brown. *Made at St Ives, 1946*

29 Rectangular Stoneware Bottle-Vase
Height 8 in.

The willow pattern was engraved and combed through a coating of black slip and after biscuit firing the pot was dipped into a semi-opaque glaze. *Made at St Ives between* 1940 *and* 1950

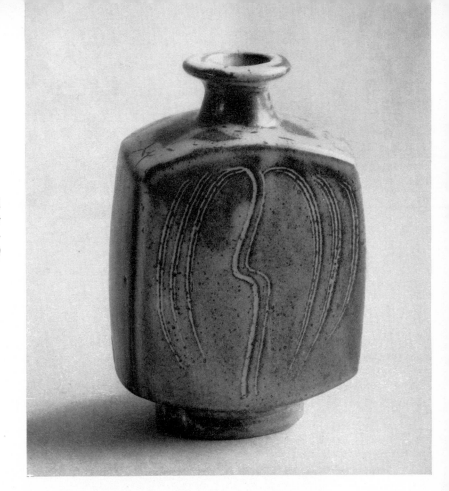

30 Stoneware Coffee-pot Height 6 in.

There is an influence from thirteenth-century English earthenware in the form of this coffee pot, although there was no coffee in England at that time, nor did the pitchers have lids. The pouring lip was added under the rim and the wall pierced to avoid distorting the seating of the lid, leaving it under the safe control of the user's thumb. The running olive-green glaze was first discovered in China at least 2,000 years ago and is a 50-50 per cent. mixture of clay and wood ash. *In personal use. Made at St Ives,* 1965

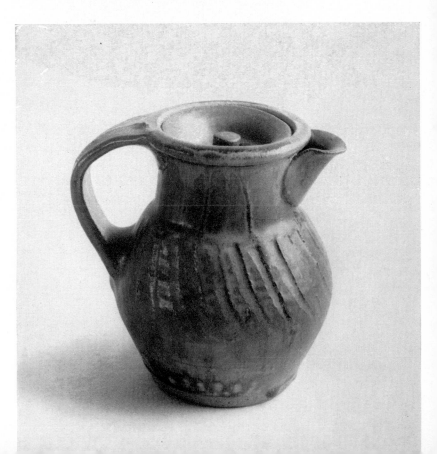

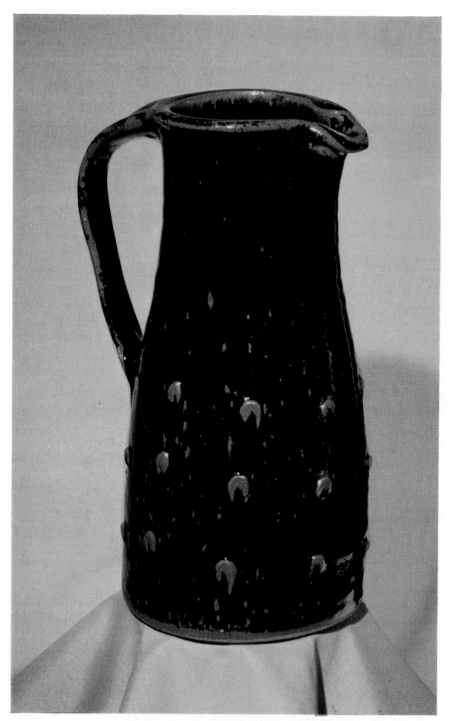

VIII **Stoneware pitcher** Height 12 in.
Black and rust 'Tenmoku' glaze. *Made at
St Ives in* 1966

31 Stoneware Vase Height 10 in.

Black or white inlay on grey, or grey-green
stoneware was an achievement of Korean
potters in the twelfth century A.D. The
body of the pot when leather hard was
scored, or indented, and then basted with
thick slip. When this had set, the whole
surface was pared down until the pattern
emerged clear-cut. This is one of the most
delightful techniques in the whole field
of potting. *Made in St Ives, 1965*

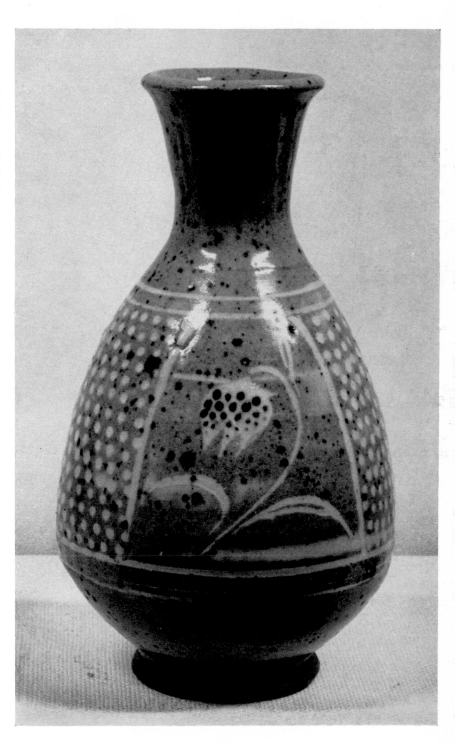

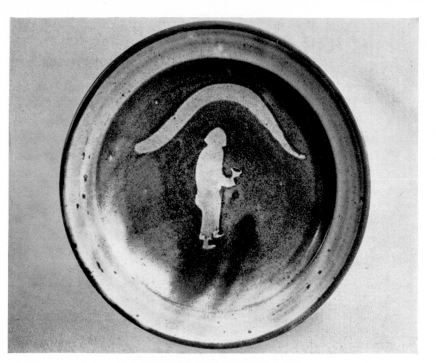

32 Stoneware Plate Diameter 13 in.

The pattern of a pilgrim and mountain was done with a paper stencil which was first stuck to the raw clay. Then the whole surface was brushed with black slip and the stencil removed. *In the National Craft Museum, Tokyo. Made at St Ives*, 1953

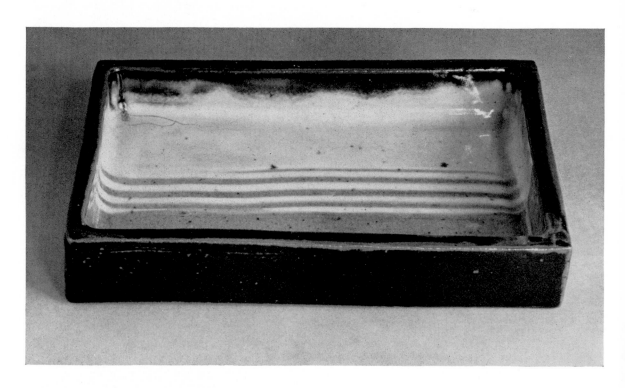

33 Rectangular Stoneware Dish 8 × 5 in.

This rectangular tray, or dish, was made without any mould. Pale celadon glaze over combed white slip inside, and black tenmoku outside. *Made at St Ives*, 1960

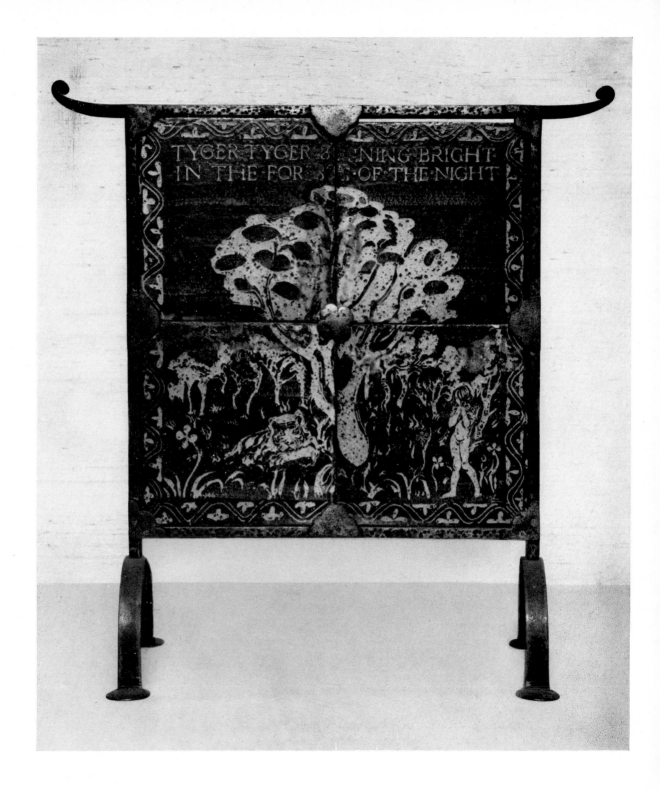

34 Stoneware Tile Set, 'Tiger, Tiger' 18 × 18 in.

The ironwork in this tile set was done from my design by the Cornish smith, Mr A. Carne, of Truro. The subject was Blake's well-known poem. The technique was *sgraffito* through iron pigment. *In the National Craft Museum, Tokyo. Made at St Ives*, 1942

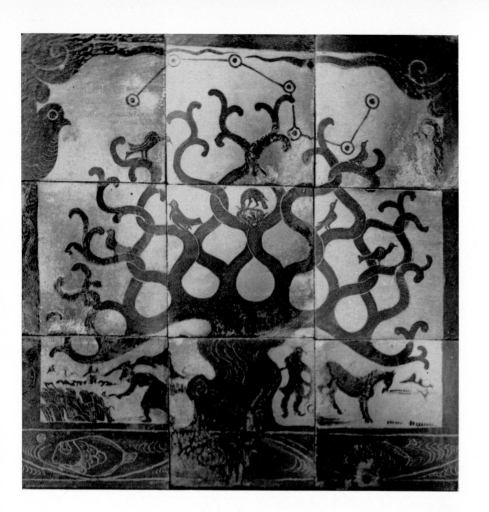

35 Stoneware Tile Set, 'Tree of Life
 27 × 27 in.

The technique is brushwork combined
with *sgraffito* through iron pigment
The subject is derived from very old
traditions and may be regarded as
symbolic. I do make decorations at
times which are abstract in character
but have no desire to limit myself in
this way. *Made at St Ives*, 1940

**36 Stoneware Tile Set, 'Well Head and
 Mountains'** 27 × 27 in.

This is part of a collection of modern pottery
presented by the late Dean, Milner White, to
York Art Gallery. The technique is *sgraffito* and
brushwork with an iron pigment which varies
in colour between black and raw rust red. I
would not describe this subject matter as sym-
bolic. The design is imaginary but derived from
things seen and felt in the mountains of Japan,
although the various elements had, to me, a
long-term significance of a pictorial kind. *In the
York Art Gallery. Made at St Ives*, 1940

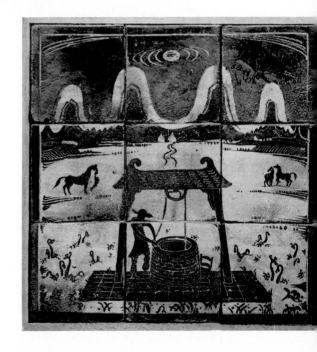

37 Stoneware Tile Set 12 × 12 in.

These tiles were made at the Leach Pottery for many years for fire-place surrounds. The decoration was done by me with iron and sometimes quiet blue. *Made at St Ives*

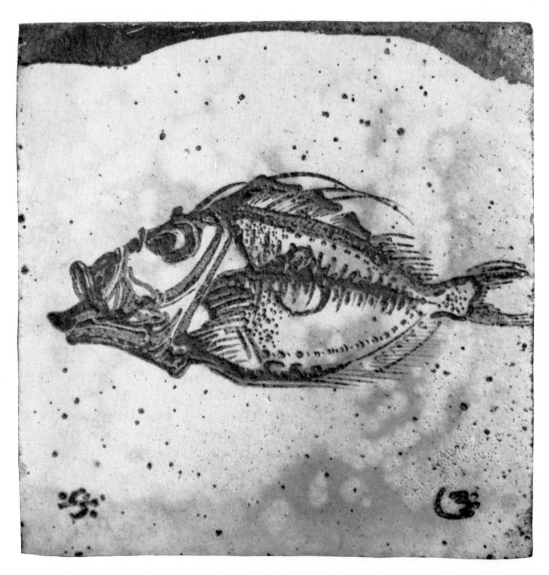

38 Stoneware Tile, 'John Dory' 9 × 9 in.

A fairly graphic representation of the fish in brushwork and *sgraffito* with iron pigment.
In order to add to its rhythmic character, I have drawn some of the bony structure
below the surface. *Bought by the Contemporary Art Society. Made at St Ives, 1940*

39 Stoneware Tile 6 × 6 in.

Painted in iron and pale cobalt under the glaze. The
breaking wave and rock pattern derived from
observation along the north Cornish coast. *Made at
St Ives*, 1950

40 Stoneware Tile 4 × 4 in.

Korean landscape and willow tree painted in iron
and cobalt wash. *Made at St Ives, about* 1960

41 Stoneware Tile, 'The St Ives Climbing Kiln'
4 × 4 in.

Made in the early days when we fired entirely with wood. *Sgraffito* through iron pigment. The flames pass up, over and down each of the three chambers in succession. In those days a firing took 35 hours; today, mainly using fuel oil, the time is less than 25 hours. Each chamber holds about 500 average pots. *Made at St Ives*, 1950

42 Stoneware Tile, 'Cornish Blackthorn'
4 × 4 in.

Between 1920 and 1960 we produced a large number of small tiles to be used mainly for fireplaces. About ten per cent. of them were decorated by me in a variety of painted or engraved patterns. The constant fast repetition of such motifs, no two precisely the same, results in a kind of abstraction, in which brush and material play an important role. Patterns are akin to dances and melodies. *Made at St Ives*, 1950

43 Stoneware Tile Set, 'Winter Landscape' 9 × 18 in.

These two tiles, painted in iron, show an influence from Chinese 'Literati' painting of the Ming Dynasty, but the simplifications were done from a rapid sketch direct from nature. *Made at St Ives*, 1960

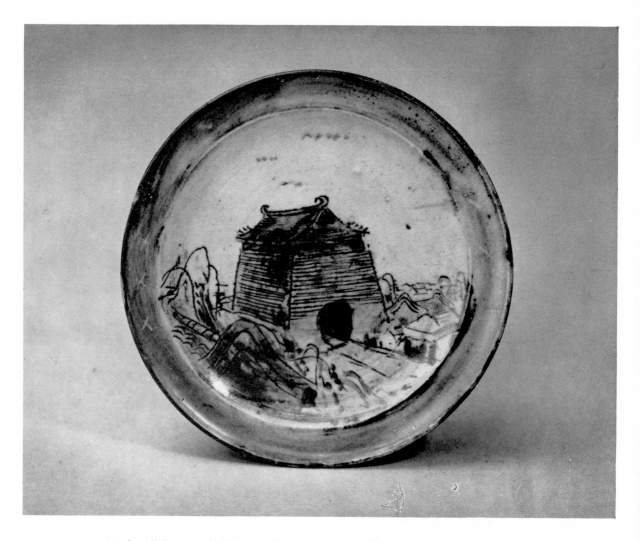

44 Small Porcelain Plate Diameter about 6 in.

I have included this photograph, not because I feel that the design (a memory of life in Peking) is a successful pattern for the centre of a circle, but because it illustrates a technique of engraving the clay surface, and then applying washes of quiet blue, which developed from pen and wash drawing and my early experience of etching. *In the Hanley Museum, Stoke-on-Trent. Made at St Ives, about* 1927

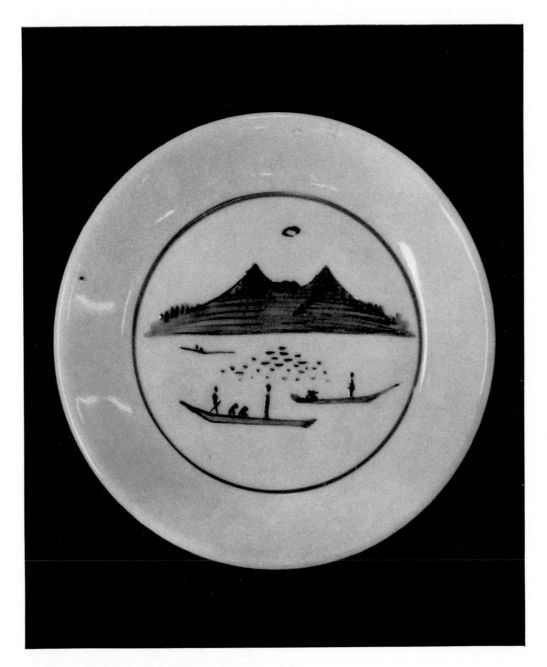

45 Enamelled Porcelain Plate Diameter 8 in.

I made two working visits to this old porcelain centre and used the traditional clays, glazes and enamels. The enamels were, black, blue-green and red. The subject depicted was first sketched on Lake Shinjiko. *Made at Kutani*, 1954

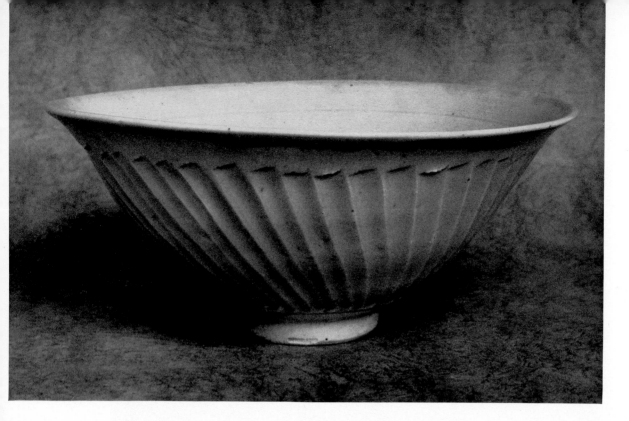

46 Porcelain Bowl Diameter 9 in.

This fluted porcelain bowl still seems to me to be one of the best porcelain shapes which I have done. I feel that it is true to the fine white and semi-translucent nature of the material of which it is made. The fluting is free-hand with a very simple strap-iron tool which takes one shaving after another from the outside of the pot, adding a rhythmic counterpoint to the circle of the bowl. This also adds variation to the thickness and colour of the pale blue-green colour of the celadon glaze.

The interior is incised and combed for the double purpose of minor orchestration and variety, within a single over-all concept of form. *Made at St Ives*, 1950

47 Fluted Porcelain Cup and Saucer
 Diameter 5½ in.

I would have liked to have designed tea-sets and table ware for the English public, and envy Josiah Wedgwood that privilege, but I would have had to own a factory, and I had neither the talent, the desire, nor the money to do this. *Belonging to Mrs Lucie Rie. Made at St Ives, 1953*

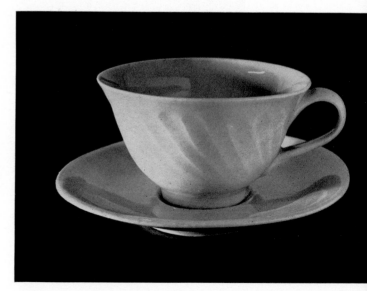

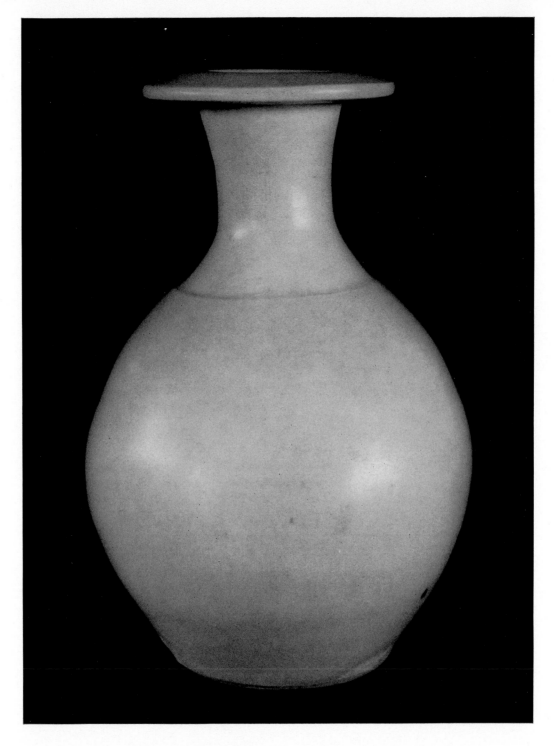

48 **Porcelain Bottle-Vase** Height 11 in.

Glazed in pale blue-green, semi-mat, Ying Ching celadon. *Made at St Ives*, 1965

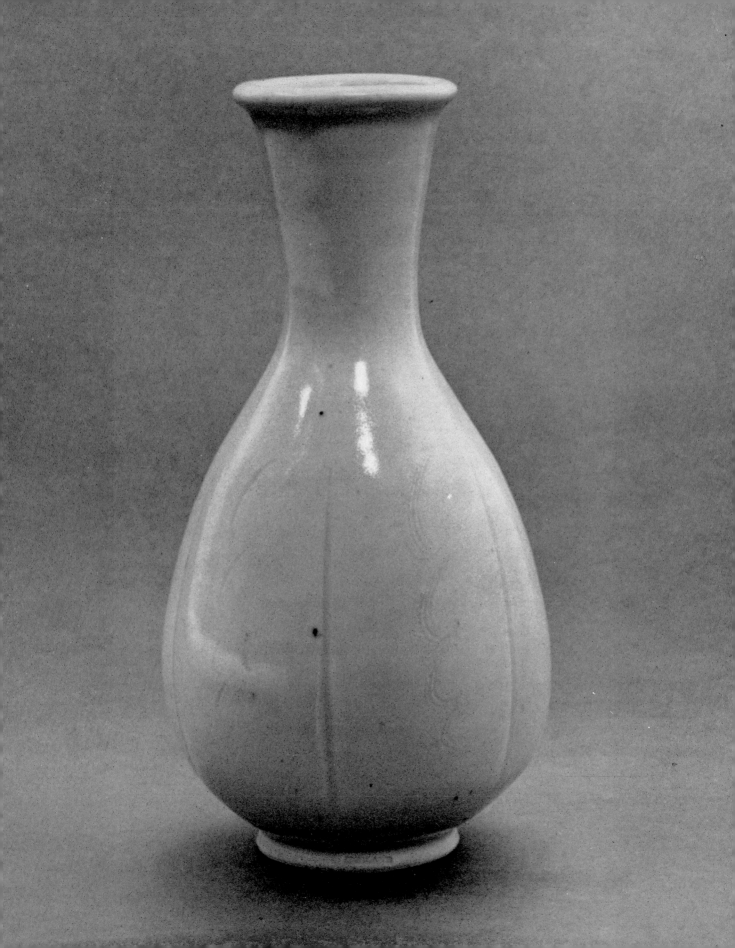

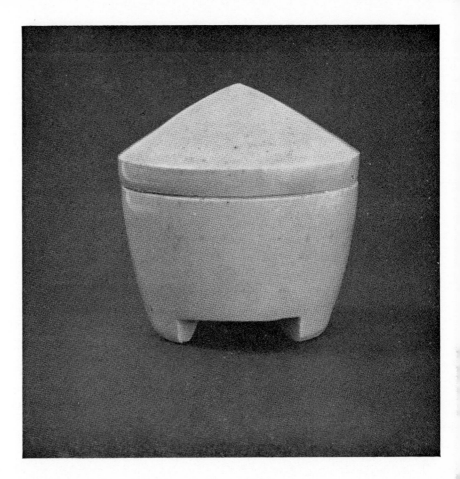

50 Covered Porcelain Incense Pot Height 4 in.

In the West the expectation is that porcelain should be translucent as well as white. This is not always demanded in the East. Korean porcelain seldom displays these characteristics. It is not necessarily thin and elegant. It is heavier and quieter in ideal. Not so white, nor so shiny; closer to jade and marble. The porcelain which we have developed in St Ives lies between the Korean and early Chinese.

The glaze on these pots is very pale bluish-green celadon. Some critics have denied that it is celadon but the definition is 'a pale green coloured porcelain glaze'. The coloration is due to a fractional content of iron oxide fired in a reducing atmosphere.

The covered pot illustrated was made to hold incense. The shape was evolved over many years from the sight of tiny rice-straw stacks which border the paddy fields of Japan in autumn and winter. *Made at St Ives*, 1965

49 Porcelain Bottle-Vase Height 9 in.

Incised and engraved porcelain vase with a pale blue-green glaze. *Made at St Ives*, 1961

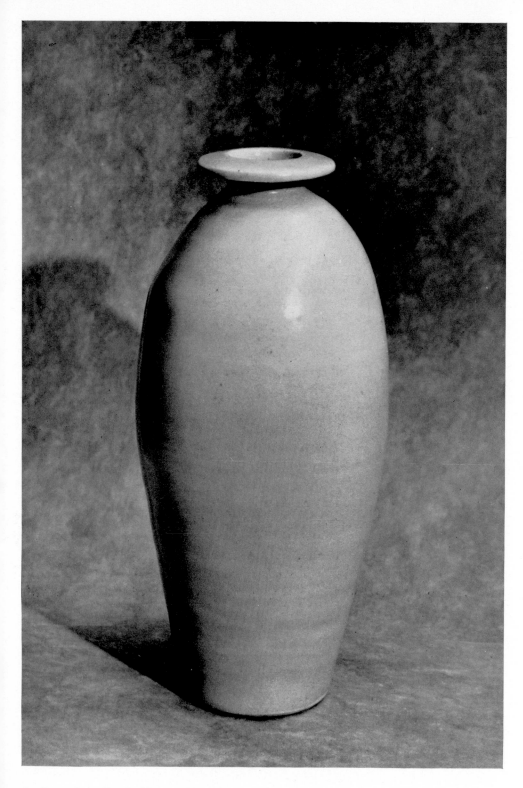

51 **Porcelain Bottle-Vase** Height 11 in.

Glazed in pale blue-green Ying Ching celadon. *In the Leach Pottery permanent
collection. Made at St Ives,* 1965

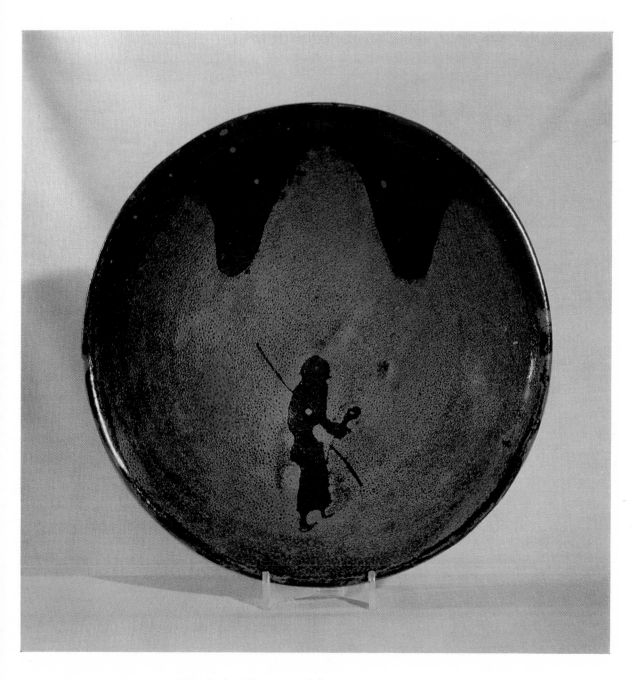

IX **Stoneware Dish, 'The Pilgrim'** Diameter 13 in.

This dish was first of all dipped into a dark olive-blue glaze, then a paper stencil was applied to the surface and the red-brown glaze called 'Kaki' was poured all over, and finally the stencils were removed. *In the Leach Pottery private collection. Made at St Ives, 1965*

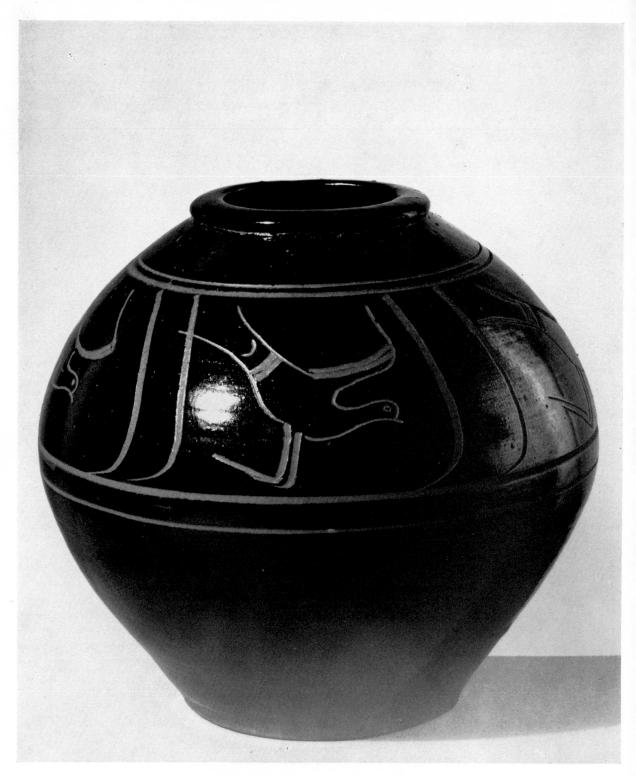

52 **Stoneware Jar** Height 13 in.

This jar was made at the potter's village of Onda in the southern island, Kyushu. The black 'Tenmoku' glaze was put on to the raw pot, which enabled me to engrave a 'swallow' pattern through it to the clay body. *Made in Japan*, 1954

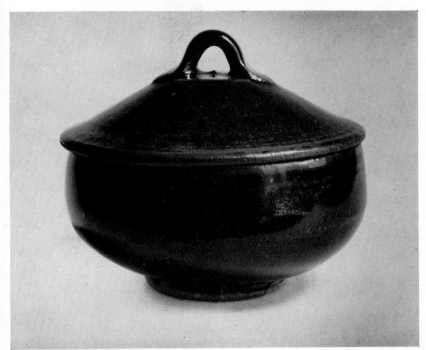

53 Covered Stoneware Sugar Bowl
 Diameter 6 in.

Glazed in a broken, black to rust, 'Tenmoku'. *Belonging to Mrs Lucie Rie. Made at St Ives, about 1958*

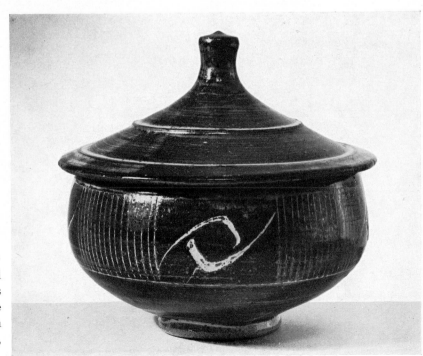

54 Covered Stoneware Pot Diameter 15 in.

In this large covered stoneware bowl decorated with *sgraffito* through black slip, the inspirations have been curious. The lid or roof from the Temple of the Moon in Pekin and the dual sun pattern from South America. *Made at St Ives, 1950*

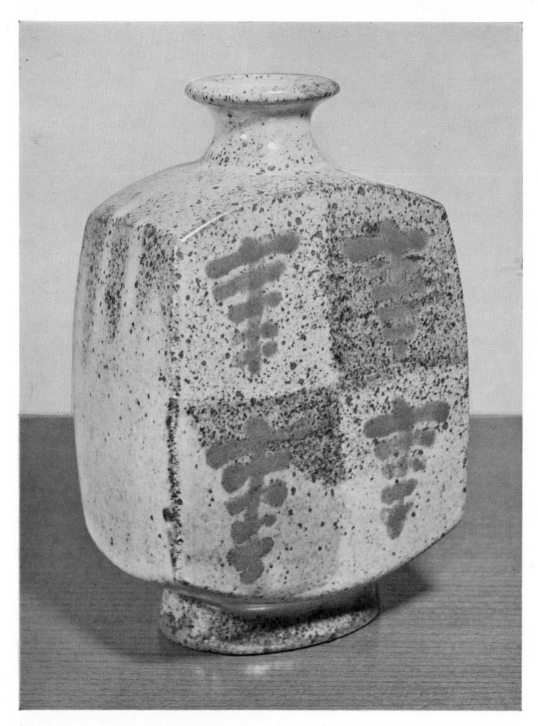

X **Moulded Stoneware Bottle-Vase** Height 8 in.

This rectangular bottle was made in a two-piece press-mould, the neck and foot
being added later. The tomato-red 'tree' pattern trailed over a white matt glaze
is a stoneware glaze which I discovered by chance. *Made at St Ives*, 1965

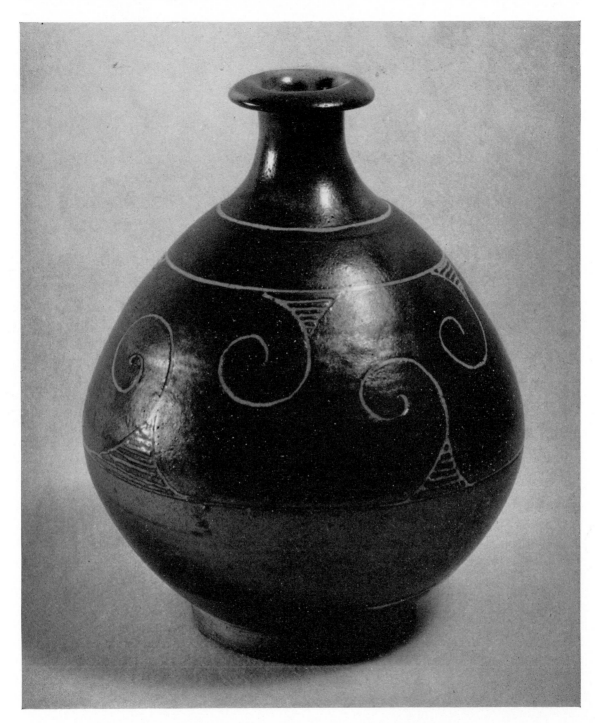

55 Stoneware Bottle-Vase Height 12 in.

The *sgraffito*, or scratched, decoration was done with a chisel-headed bamboo tool when this pot was leather-hard. The object was to enrich and accent the form with a few rhythmic, clean and meaningful lines. *Made at St Ives, 1961*

56 Stoneware Bottle-Vase Height 11 in.

The change of colour from black to red can be
seen in this fluted vase. The cause is the thinness
of the glaze on the edges. The melted glaze
recedes into the fluted depressions. The thin
residue can then accept both silica and iron from
the clay causing an alteration of colour in the
clear burning oxidizing flame of the last part of
the firing. $Fe_2 0_4$ into $Fe_2 0_3$. *Made at St Ives,
1961*

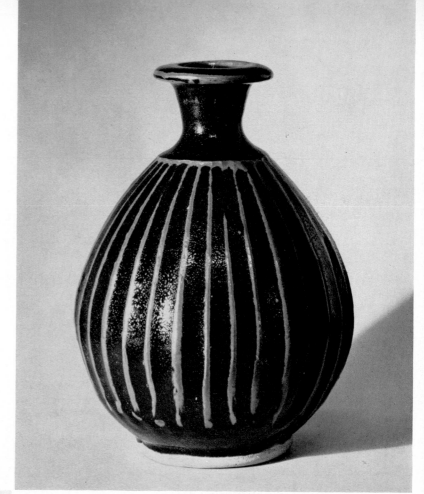

58 Covered Stoneware Pot Height 12 in.

The scoring on the sides of this bread-bin is done
with an iron tool like a chisel. It is held at a
slight angle so that one side of the cutting edge
bites deeper into the clay as it is dragged in one
movement from top to bottom. This gives life to
the strokes and causes the black glaze to turn
brown on the sharp edges and thus yield more
variety of colour. *Made at St Ives, 1962*

57 Stoneware Bottle-Vase Height about 14 in.

This large engraved stoneware bottle-vase is glazed in broken,
black to rust, 'Tenmoku'. *Made at St Ives, 1960*

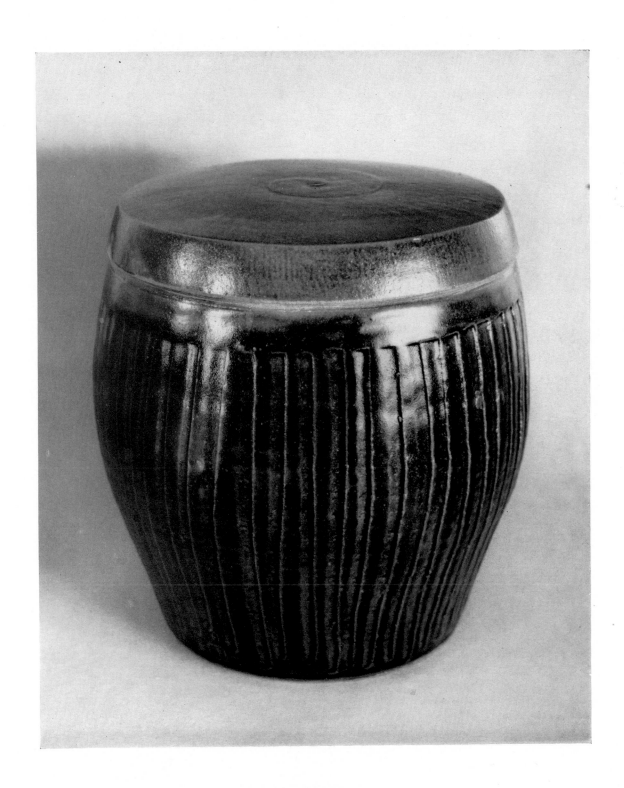

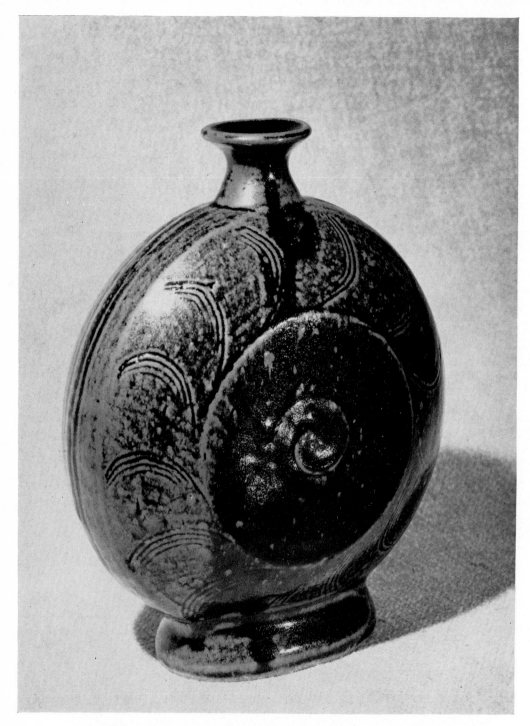

59 Stoneware Bottle Height 15 in.

Flattened 'pilgrim' bottle, made by joining two shallow thrown bowls and adding separate neck and foot. The surfaces have been combed and cut to display the variegated effects of thin hard-fired 'Tenmoku' glaze. *In the Victoria and Albert Museum. Made at St Ives*, 1956

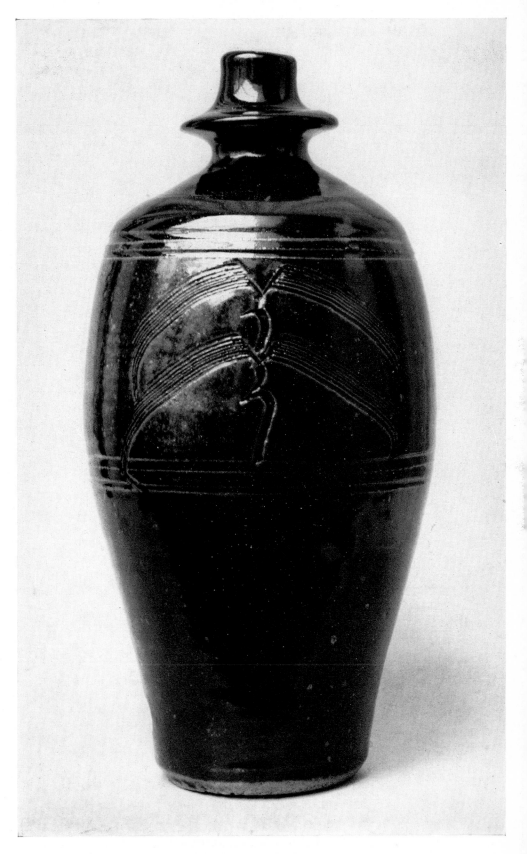

60 Stoneware Bottle
 Height 15 in.
In this engraved 'Tenmoku'
bottle with a flanged lip, I have
sought a strict relationship of
form in terms of material and
tools. The fact that it has some
resemblance to a human figure—
a long shank, a belly, a shoulder,
and a neck, is secondary. The
naturalism does not, I feel,
falsely invade the sphere of
abstract form with its own
implicit laws. *Made at St Ives*,
1962

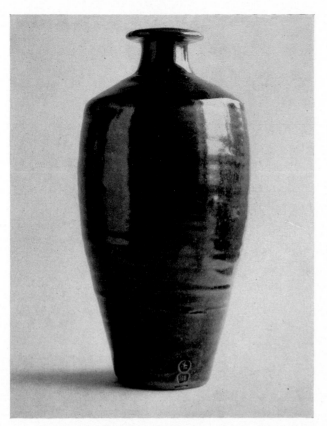

61 Stoneware Bottle Height 13 in.

This tall, black bottle illustrates tolerably well certain principles of form, or shape, to which I have adhered over the years. A clean rise to the major statement, the belly of the pot; in this case, a sharply accented shoulder, then the concave movement of the narrow neck, which adds fullness to the main curve below, and finally a flanged lip with a straight downward top surface to include it with the hidden sphere which most pots contain. *Made at St Ives*, 1965

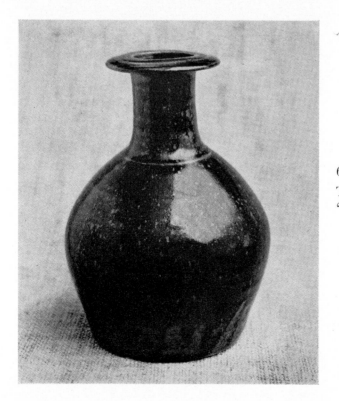

62 Stoneware Bottle-Vase Height 11 in.

This bottle-vase is glazed in mottled black to rust, 'Tenmoku'. *Made at St Ives*, 1965

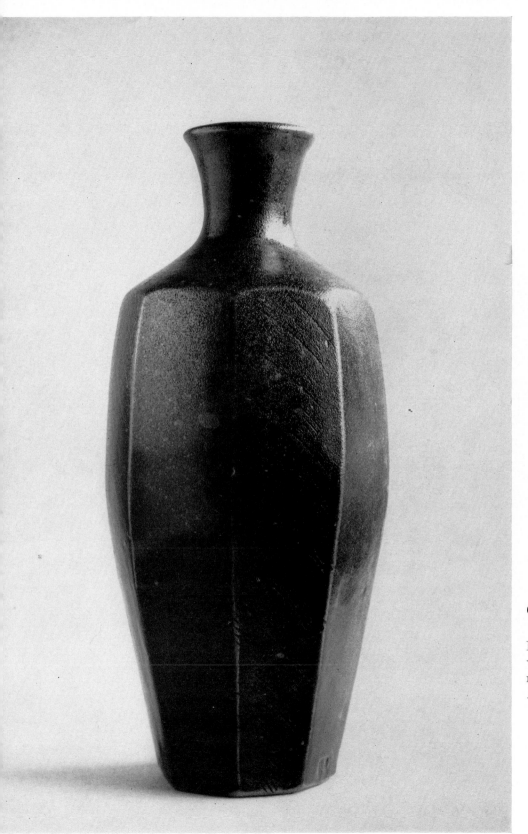

63 Stoneware Bottle-Vase
 Height 11 in.

Engraved and cut-sided bottle-vase in frosted 'Tenmoku' glaze rusted on the angles. *Made at St Ives*, 1963

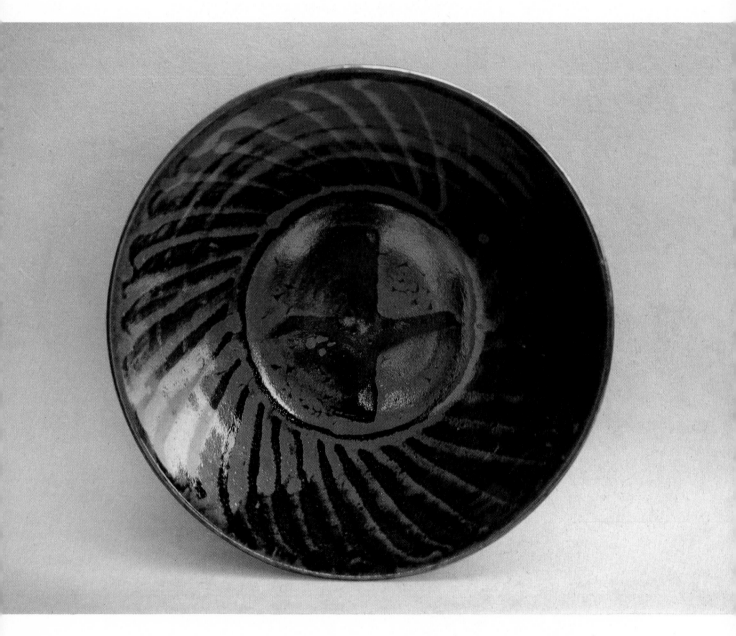

XI **Stoneware Dish** Diameter 14 in.

The same two glazes were employed as in Plate IX but instead of stencils, a wax-resist pattern was painted between the dark blue and red-brown glazes. I was delighted when this pot emerged from the kiln because the glaze effects were better than I could have anticipated. *In the Leach Pottery permanent collection. Made at St Ives*, 1965

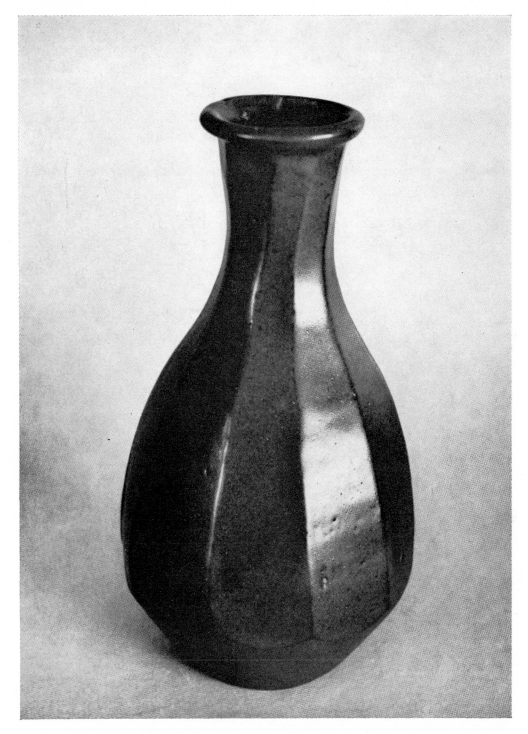

64 **Stoneware Bottle-Vase** Height 8 in.

Dark olive-blue, cut-sided stoneware vase. *Made at St Ives,* 1962

65 Dark Olive-Blue Covered Stoneware Pot
 Diameter 14 in.

For cutting such facets I use a small wooden jackplane with a deeper slot for the steel blade to allow room for thicker shavings of clay than of wood. *Made at St Ives, 1962*

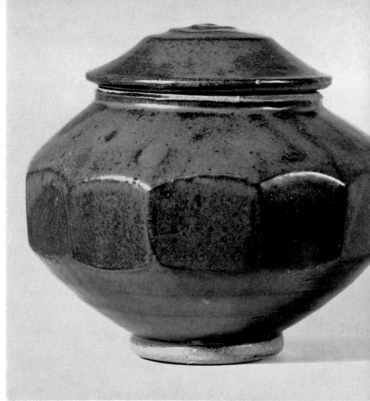

66 Stoneware Bottle Height 16 in.

I feel that this plain black 'Tenmoku' bottle has a classic rightness of proportion. This raises the question of what constitutes classicism when we are no longer limited to Greek or Renaissance standards. My hope and belief is that we possess a latent capacity to expand our concepts of what is true and beautiful, to cover the experience of mankind as a whole. *Made at St Ives, 1962*

67 Stoneware Bottle (OPPOSITE) Height 15 in.

This stoneware bottle, glazed in 'Tenmoku', was thrown on the wheel and then beaten and shaved to a square section. *In the St Ives Pottery permanent collection. Made at St Ives, 1963*

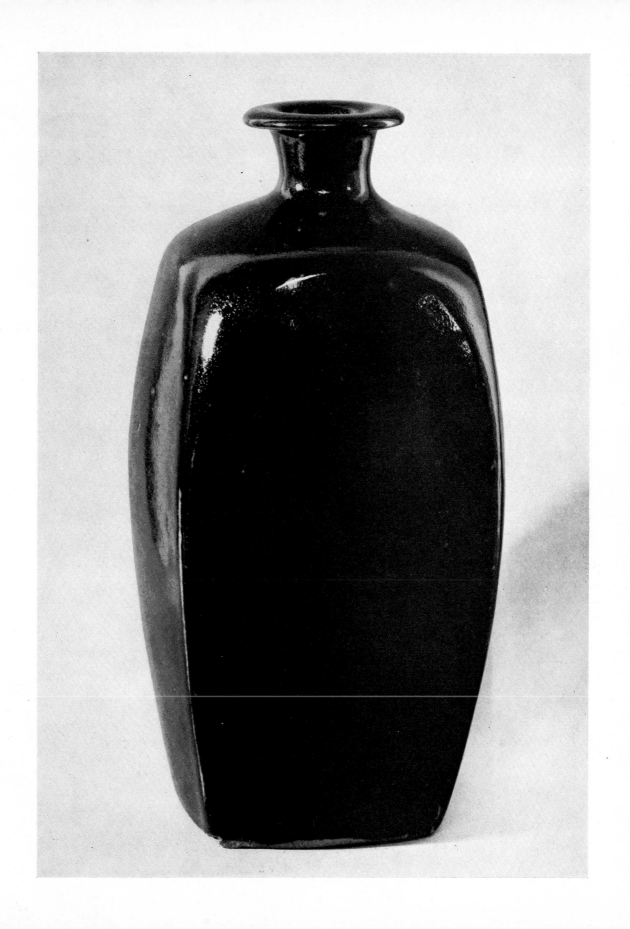

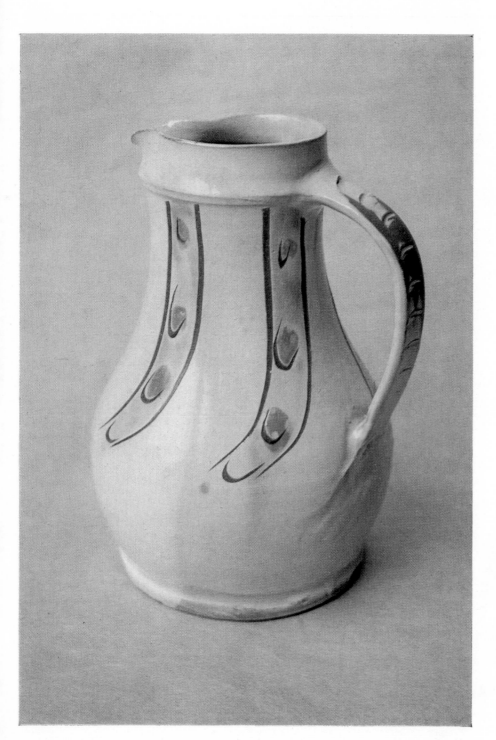

XII **Stoneware Pitcher** Height 11 in.
This jug was made at the remote
mountain village of Onda, where the
kilns are fired with predominatingly
clear flame which enables the potters
to obtain a green glaze from copper
oxide. I taught these, and other,
village craftsmen how to 'pull' and
place handles on jugs and cups, for
this technique was not part of the
Japanese tradition. *In the National
Craft Museum, Tokyo. Made in
Japan,* 1954